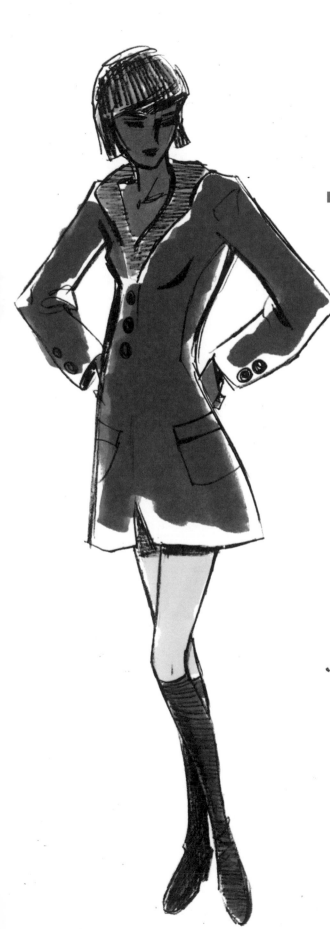

DRAWING WITH Chris Hart

Fashion Design Studio

Learn to Draw Figures, Fashion, Hairstyles & More

creative girls draw

sixth&spring books

New York

For my wife, Maria, without whom this book could not have been written.

An imprint of Sixth&Spring Books
161 Avenue of the Americas, New York, NY 10013
sixthandspringbooks.com

Editorial Director JOY AQUILINO	Book Design PETER ROMEO	Production Manager DAVID JOINNIDES
Developmental Editor LISA SILVERMAN	Proofreader DARYL BROWER	President ART JOINNIDES
Art Direction STUDIO2PT0	Vice President TRISHA MALCOLM	Chairman JAY STEIN
Editorial Assistant JOHANNA LEVY	Publisher CAROLINE KILMER	

Library of Congress Cataloging-in-Publication Data
Hart, Christopher, 1957–
Fashion design studio : learn to draw figures, fashion, hairstyles & more / Chris Hart.
 pages cm. — (Creative girls draw)
ISBN 978-1-936096-62-6 (pbk.)
1. Fashion drawing—Juvenile literature. I. Title.

TT509.H37 2013
741.6'72—dc23
2013023426

Manufactured in China

9 10 8

First Edition

contents

getting
started

Have you ever wanted to draw fashions? What about drawing trendy models in eye-catching outfits? Now you can do both. This book will show you how to draw fashion figures in the outfits that make them sparkle. If you've tried to draw from the photos in fashion magazines, you'll know that photographic reference material doesn't take you very far. It provides no foundation. And without that, it's difficult to improve.

The lessons in this book give you all the basics, which make drawing easy and fun. There's no more struggling to get it right. And because the techniques are grounded in real art principles, practicing with this book can make you a better artist in any genre, not just fashion. You'll enjoy learning to draw pretty eyes and features, stylish hairdos, attractive figures, cool outfits, fashionable poses, folds, creases, and even patterns. There's everything from elegant evening dresses to retro-chic outfits, bags, shoes, and boots.

All right, all you fashionistas, it's time to get your pencils. We are ready to get started.

You can begin drawing great fashion illustrations with just a pencil and paper. But suppose you'd also like to explore color? Maybe you would also enjoy using an art pencil. Or you might want to know if there's anything you can obtain from an art store that is designed to correct mistakes. The good news is that art supplies for illustrators are reasonably priced. Unlike painting or sculpting supplies, they don't make a mess, unless you decide to eat and draw at the same time, which I don't generally recommend.

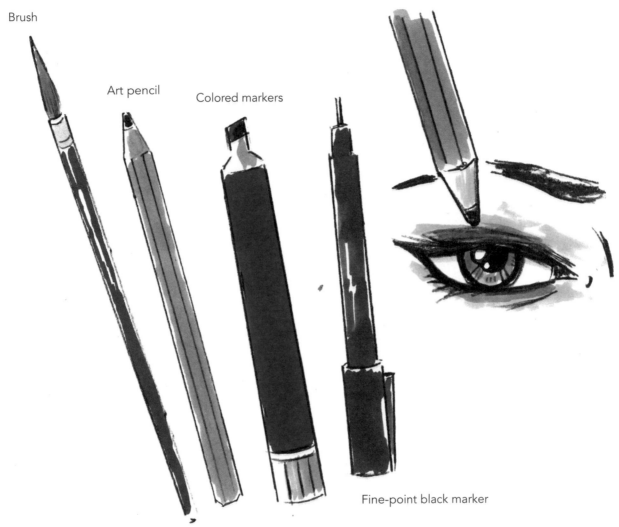

Brush

Art pencil

Colored markers

Fine-point black marker

your basic
art supply list

- A set of art pencils
- A big, fat eraser of any type
- Art stores have a variety of products that remove or mask mistakes.
- Some products that mask mistakes require a thin brush to apply them.
- Small plastic cup for cleaning the brush, if you decide to get one
- Fine-point black marker
- Set of colored markers
- Set of colored pencils
- Pencil sharpener
- Pad of paper. Avoid rough paper, glossy paper, tracing paper, and newsprint
- A 12–18" ruler

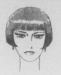
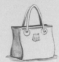

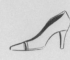

optional

- Light box
- Templates for basic shapes
- Triangles
- Inking ruler (has a raised edge so that ink doesn't smear)
- Folders to categorize your drawings

Light box

Sharpeners

6

setting up **your workspace**

Your work area can be as basic as a chair and a kitchen table. But even if you want to go further and set up some studio space for yourself, you don't need much more room than would be taken up by a drafting table and a chair. A corner of the den, the guest room, that extra space over the garage, or a converted basement or attic will work just fine. This could be a good excuse to finally clean up the basement!

Lay out the space so that everything is well within reach, and you're not always jumping up and down or stretching to grab the necessary items, like reference material.

studio **essentials**

- **Inexpensive but non-wiggly drawing desk**
- **Drawing chair**
- **Old coffee tins to toss supplies in**
- **A stack of horizontal file drawers on wheels, called a "tabouret," or some cabinet space. Your drafting table may have a drawer, or built-in holders for pencils and supplies. Plus, the surface of the table may be big enough for your basic supplies.**
- **Shelf space for reference materials and how-to-draw books by some guy named Chris**
- **Desk lamp**
- **Wastebasket—hey, they can't all be masterpieces!**

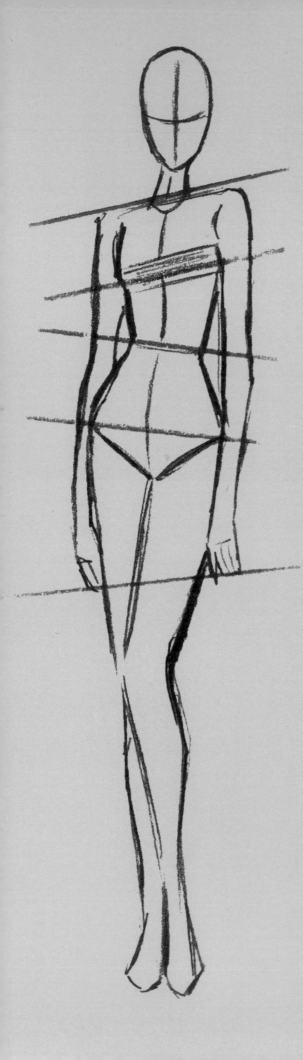

the fashion figure

The body is a machine, with many components and movable parts. But fashion illustration isn't representational figure drawing. Total accuracy would leave no room for style. In order to create a figure that can be heavily stylized, we need to simplify it. Therefore, let's look at the body as a series of segments. Our job is to put those segments together so that they flow.

Glamour, beauty, sultriness, and slinkiness can be expressed in the basic construction of the body, before any fashions are added. It must be said that attractive female models come in different body shapes and sizes, and this book features several plus-size models. However, in order to cover as much ground as possible, it's necessary to select one basic type and explore all of its aspects, rather than changing proportions and approaches every time we use a different type of model.

essential **proportions**

The average person is seven heads tall. Some people draw figures slightly longer, at seven and a half heads. However, in order to both highlight and exaggerate the length of fashion models, they are typically drawn at least eight, often nine heads tall. The more heads tall a figure is, the smaller the head will appear in relation to the body. This is how you create the look of actual height in a drawing, not the size of the figure on the page.

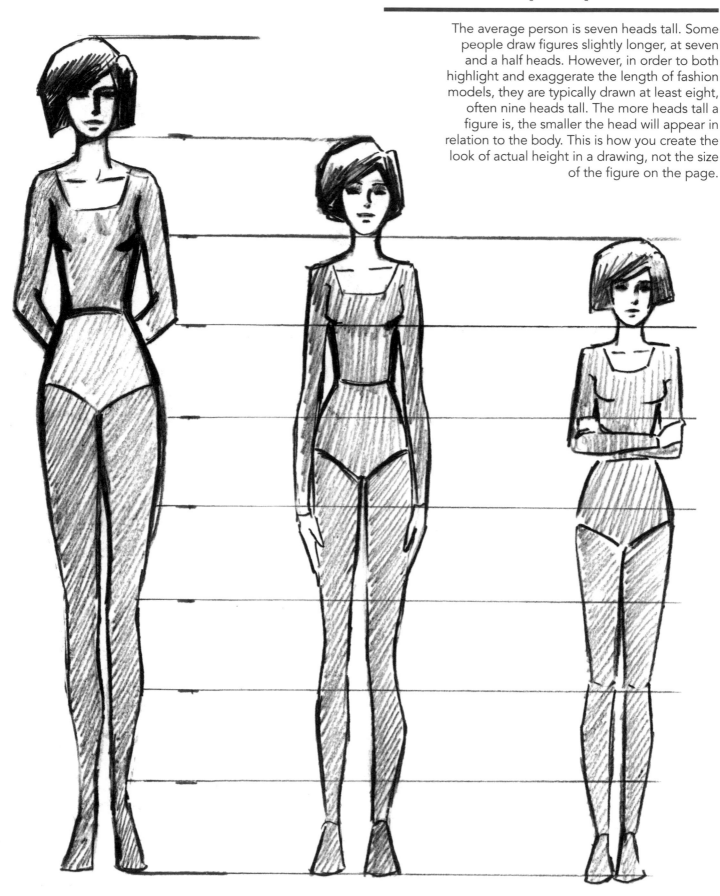

9 HEADS TALL
(fashion "illo" proportions)

8 HEADS TALL
(fashion "illo" proportions)

7 HEADS TALL
(true height)

relative length **of the legs**

Actual proportions say that the midway point on the average person, when measured lengthwise, is the crotch. This means that the legs can loosely be thought of as half of the height of the overall figure. But in fashion illustration, the legs are lengthened in relation to the upper body, so that they are no longer equal. This means that the crotch appears higher on a fashion model's figure. Why is this done? Because the legs represent the longest lines of the body, which results in striking poses.

plus **size**

Once you've mastered the standard fashion figure, you'll find it's easy to draw curvier ones. Keep the proportions the same, making sure the waist and the line of the legs remain tapered, while adding roundness and width to the frame at the bust, shoulders, and hips. You may also want to add fullness to the face, arms, and legs, but keep the taper points at the neck, wrists, ankles, and calves. Always use curves to add roundness, never straight lines.

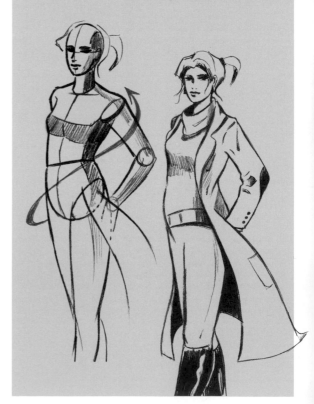

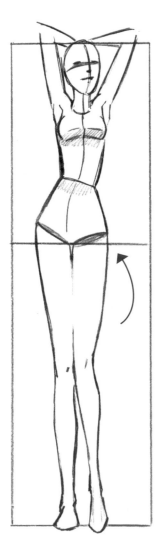

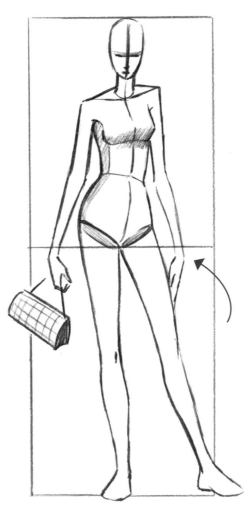

**LEGS HIGHER THAN
HALFWAY UP THE BODY**
(fashion model proportions)

**LEGS HALFWAY
UP THE BODY**
(true proportions)

the torso **at various angles**

Just as a well-constructed head can be turned at different angles and retain its basic look, the same should hold true for the body. However, that isn't to say that the body—or the torso, in particular—retains the identical shape as it is turned at different angles. Different angles reveal different curves and shapes to the body. Here are the basic four:

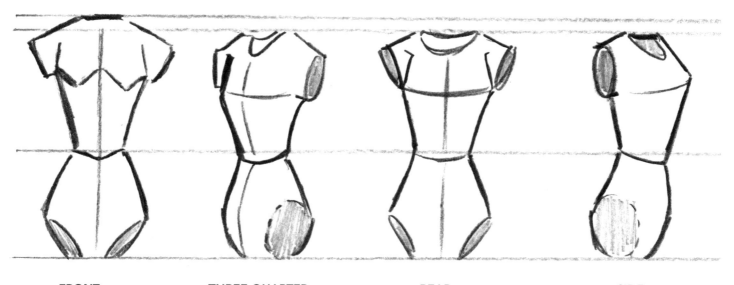

FRONT **THREE-QUARTER** **REAR** **SIDE**

Notice how the torso has a high waistline, and fits into the hips snugly. Although the construction is simplified, it's also concrete. At the later stages it can be stylized to appear loosely drawn, but it helps tremendously to begin with a solid starting point.

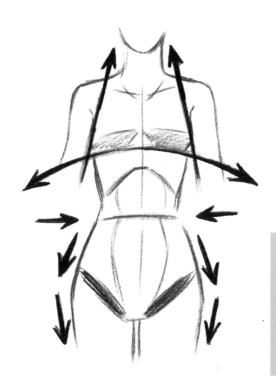

Look for the soft angles that show the directions of the torso's contours. The dark arrows in this illustration indicate some of them.

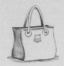

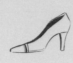

the legs **at various angles**

The legs have a natural curve to them, which is most apparent in the side view. The thigh curves outward, while the shin curves slightly inward. In the front view, we can see how the outer line of the leg, at the side of the hips, travels down and inward toward the knee.

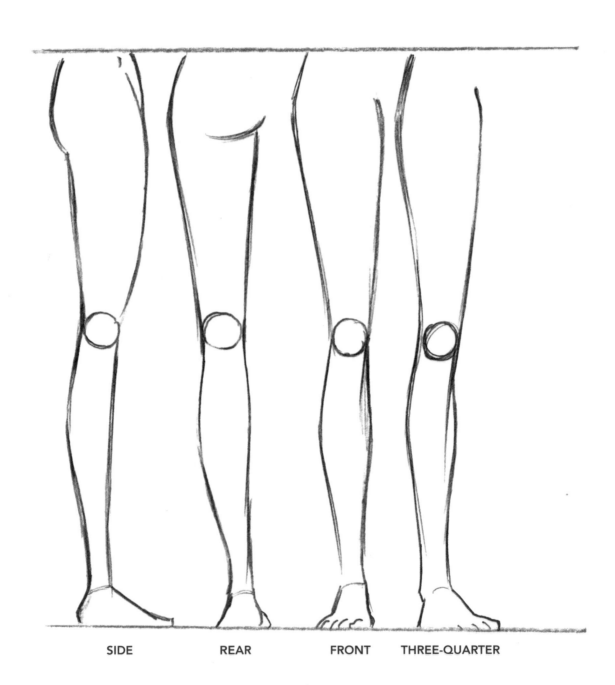

SIDE REAR FRONT THREE-QUARTER

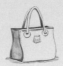

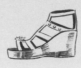
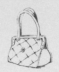

constructing **the figure**

The temptation is to dive right in and start drawing finished figures. That type of eagerness is an asset. However, by first spending a few pages drawing the basic foundation—the constructions—you will build good habits that will increase your skills.

I've developed a simplified method for constructing the body, which is based on a combination of stick figures and basic shapes. It strips the figure of the exogenous details at the outset, and allows you to concentrate on putting the essential foundation into place. Once you've done that step, simply flesh out the limbs of the stick figure, and connect the various body segments (head, torso, hips, etc.) in a smooth manner.

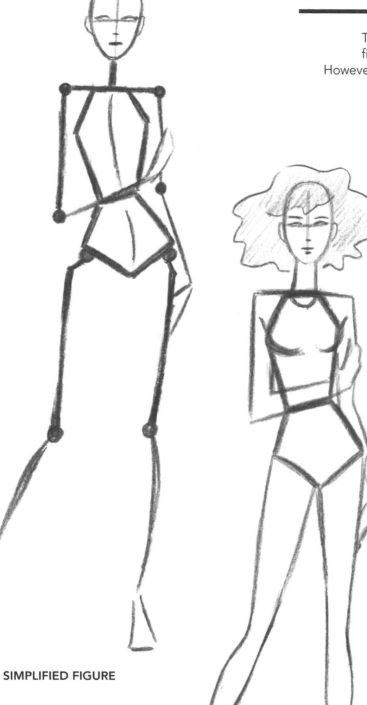

SIMPLIFIED FIGURE

FRONT

front **view**

When drawing the body, it helps to keep these four points in mind:

- Proportions
- The shapes of the various segments of the body
- The contours of the figure
- The attitude of the pose

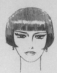 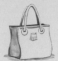 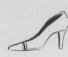

side **view**

The side view features a long, sweeping line of the back. This line is curved, most prominently at the small of the back and around the shoulder blades, just below the back of the neck.

The curves of the figure keep it looking dynamic. It's not just the pose itself.

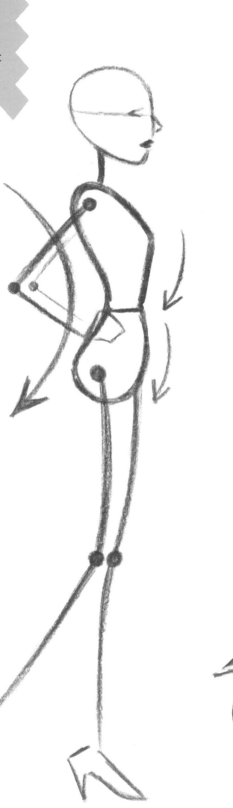

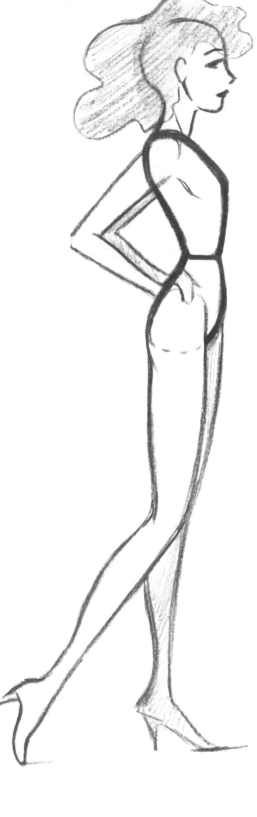

rear view

Many people are unsure when it comes to drawing the back. They worry that they haven't added enough detail. Don't worry. The less detail on the back, the better. Don't try to do too much with it, unless your figure is athletic, in which case more articulation is required. Instead, work on getting the outline right.

Note that the shoulders add width to the torso.

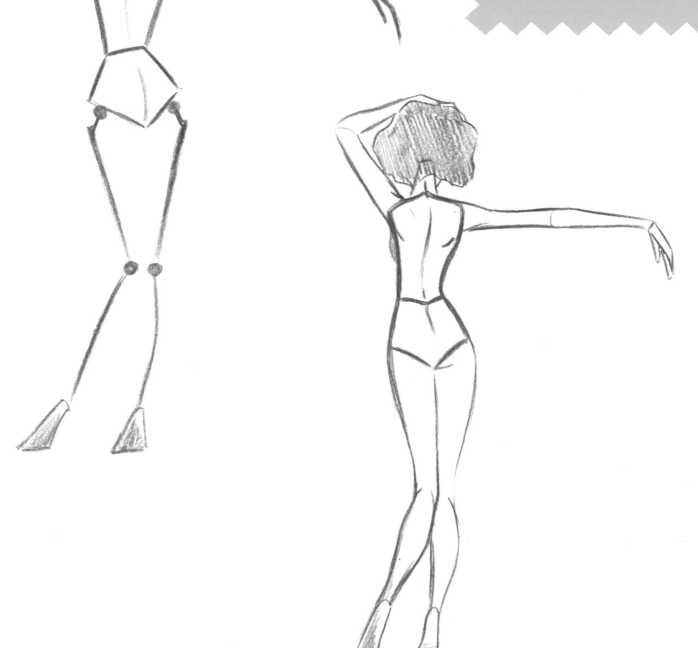

combining **angles**

Not all poses fit neatly into one of the three categories we have covered: front, side, and rear. Often a pose will feature a combination of angles. Usually, one angle is stressed over the other. For example, a side pose might be tweaked so that the torso and head twist toward the viewer at a three-quarter pose. The purpose of this is to give the pose the appearance of depth. (Side views are notoriously flat.)

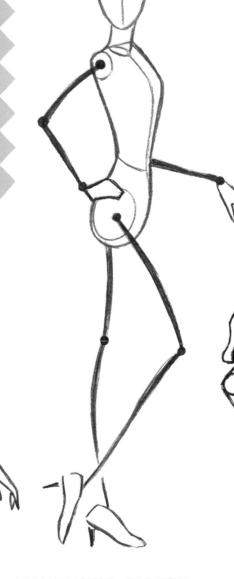

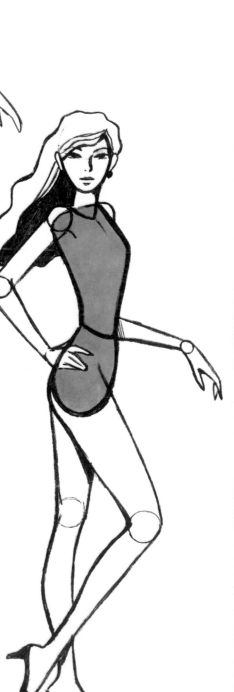

PRIMARY ANGLE—SIDE VIEW
SECONDARY ANGLE—3/4 VIEW
You can tell that the pose is not a pure side view, because if it were, you would not be able to see the far shoulder, which would be hidden behind the torso.

16

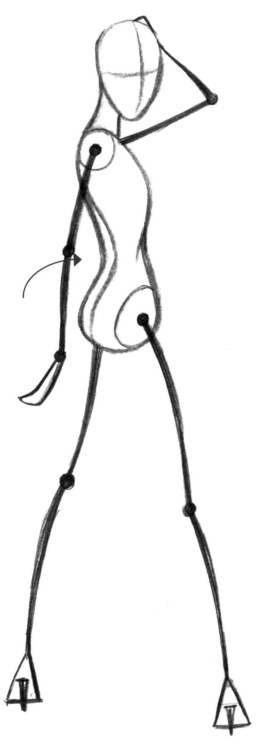

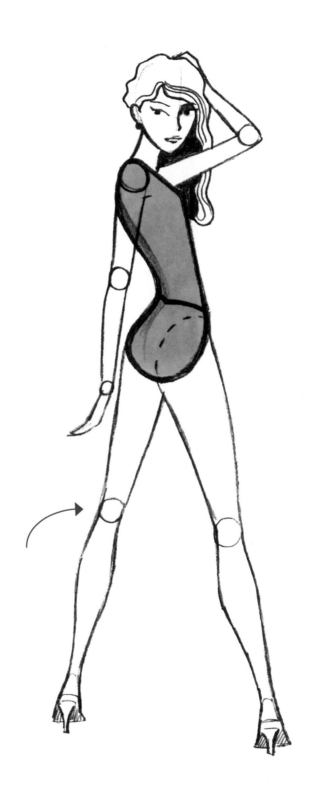

PRIMARY ANGLE—REAR VIEW
SECONDARY ANGLE—SIDE VIEW

This leg position, with both knees facing away from us and the line of the spine being apparent, indicates a rear view. The torso, however, is doing a twist toward us, mimicking a side view. This makes the pose dynamic rather than static. Pure rear poses aren't all that common in fashion illustration, because there's less to see. Therefore, when you have a rear view, consider the option of combining it with another angle.

 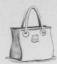 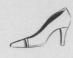

horizontal planes **of the body**

The body is highly symmetrical. The eyes, shoulders, elbows, hips, and knees are at the same height on the left side of the body as they are on the right side. But when you draw your model leaning with more weight on one leg than on the other, the symmetry goes out the window. That's because the body immediately compensates in order to maintain balance. And this means that more than just the legs shift position.

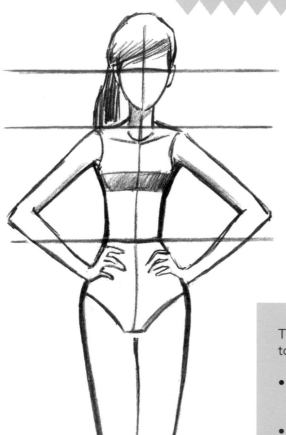

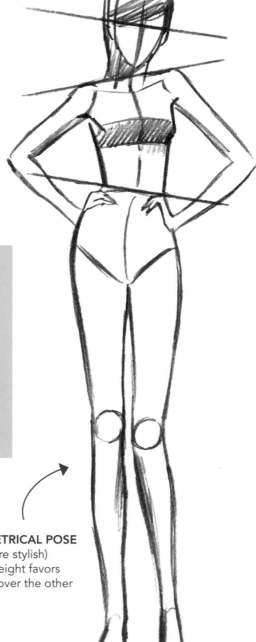

The simplified rule of thumb to remember is this:

- The shoulders and hips generally tilt in opposite directions.
- If the left shoulder is down, the left hip is up.
- If the right shoulder is up, the right hip is down.

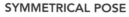

SYMMETRICAL POSE
(lacks interest)
The weight is evenly distributed on both legs

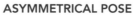

ASYMMETRICAL POSE
(more stylish)
The weight favors one leg over the other

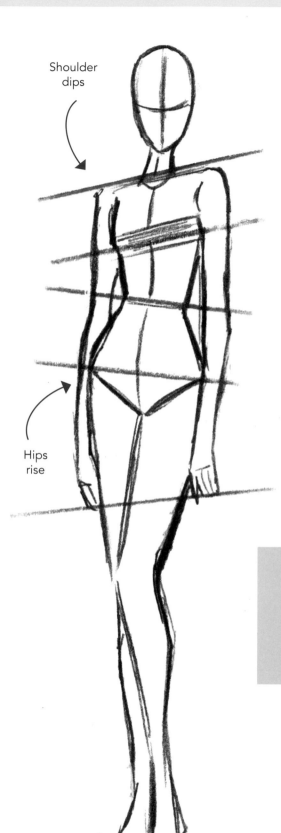

Shoulder
dips

Hips
rise

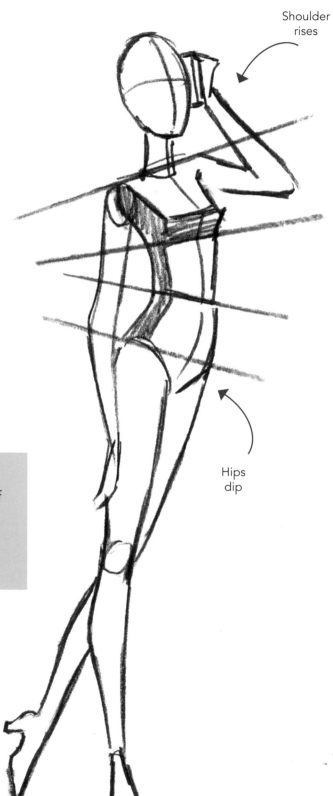

Shoulder
rises

Hips
dip

By adjusting the
horizontal planes of
the body, you add
dynamism to your
poses. There's no
substitute for it.

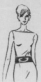

the flexible **figure**

As we've seen in the last example, adding a few turns and curves to an otherwise straight pose greatly enhances its appeal. Some how-to-draw books start you out drawing stiff poses, so that you can do them easily, before moving on to more natural poses. The problem with that approach is that it fosters bad habits.

In this book, we'll cut to the chase! We're going to draw poses that the body actually assumes, which means that the thrust of the spine will have some curve to it.

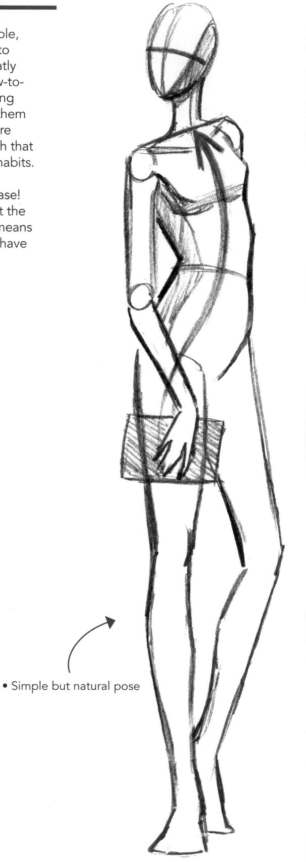

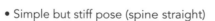

• Simple but stiff pose (spine straight)

• Simple but natural pose

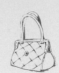
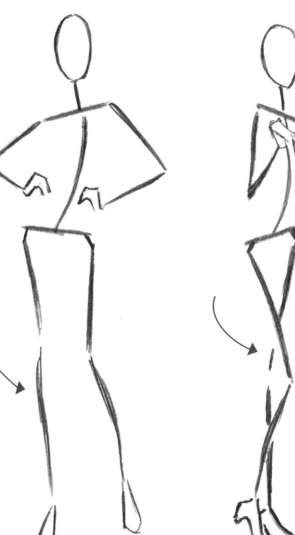

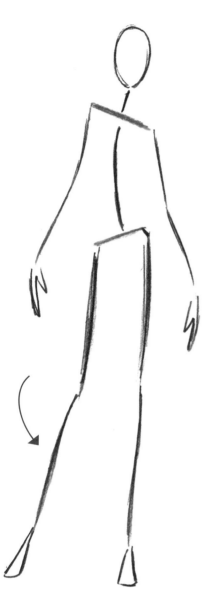

Weight on left leg

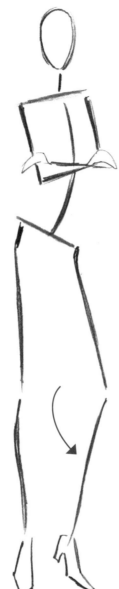

Weight on right leg

Dynamic poses can be drawn with both feet planted symmetrically on the ground. However, a natural look can also be captured by allowing the figure to place more weight on one leg than on the other The one with most of the weight on it is called the "weight-bearing leg."

So the question arises: How can we tell which leg is weight-bearing? It's simple. The leg with the locked knee, which appears to be pushing the hip up, is the weight-bearing leg. The leg with the bent knee, or the leg that is positioned away from the body, which pulls the hip down, is the non-weight-bearing leg.

Weight-bearing leg
is locked

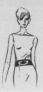

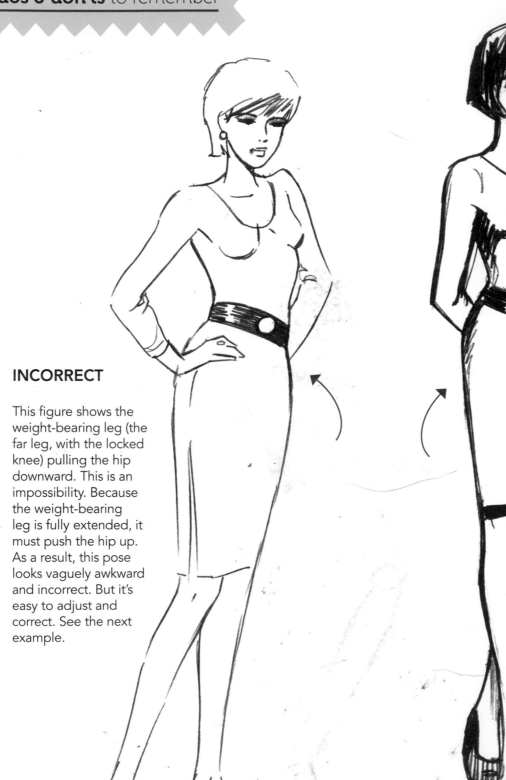

INCORRECT

This figure shows the weight-bearing leg (the far leg, with the locked knee) pulling the hip downward. This is an impossibility. Because the weight-bearing leg is fully extended, it must push the hip up. As a result, this pose looks vaguely awkward and incorrect. But it's easy to adjust and correct. See the next example.

CORRECT

The weight-bearing leg is now pushing the hip up, and the pose intuitively looks correct to the viewer, who has no idea why that is. But you do. And now that you know why it works, you can use this knowledge to figure out how to correct your drawings in the future. Not a bad deal.

draw it yourself: uneven poses

Let's practice drawing a few of these models with a special eye toward creating uneven poses, which give the body an attitiude. By "attitude," I mean that the pose communicates something about itself to the viewer. It might be saying, "I'm having fun," or "I'm wondering," or "I'm in a rush,"or "I'm shy," etc.

You can use the examples on this page, or come up with a few of your own. Let's keep this exercise loose and simple, and without much detail. That will allow us to concentrate on the overall feeling of the pose and tilting the shoulders and hips.

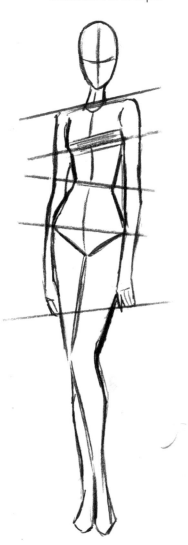

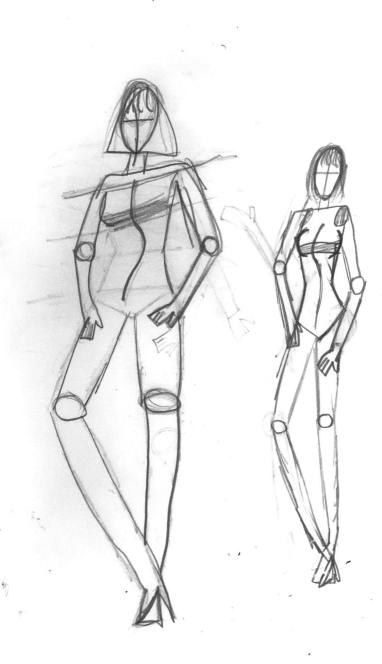

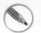

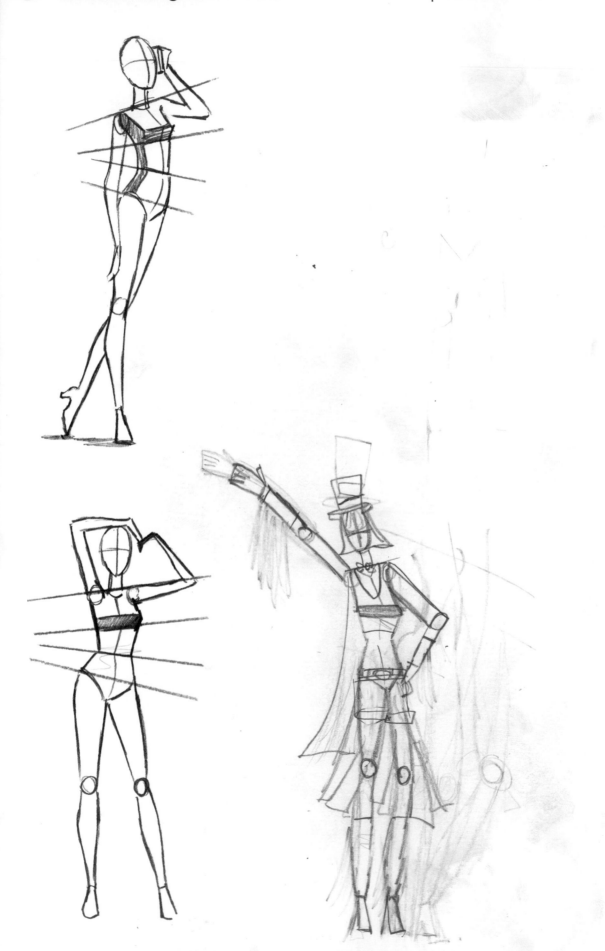

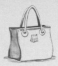

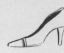

thrust of
a pose

The direction of various parts of the body, like limbs, torso, and hips, must all come together in one overall thrust for the pose.

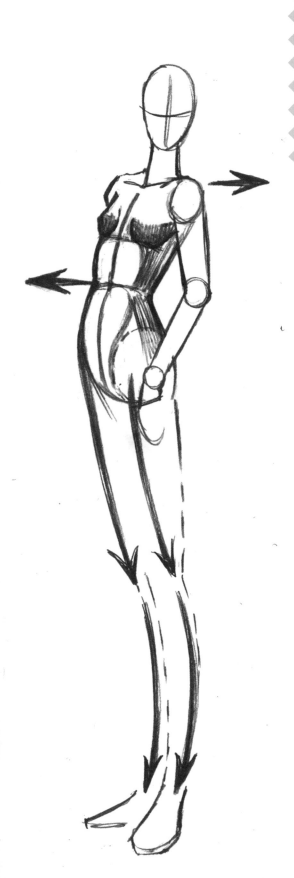

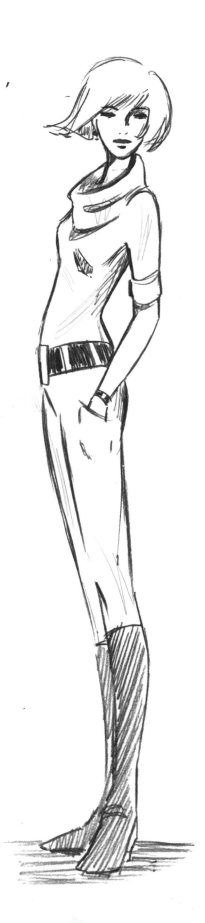

25

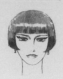
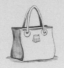

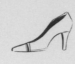

what do you do **with the arms?**

Yep, we've all run into this problem at one time or another. You've sketched a nice pose; the body dynamics and posture are working well. Perhaps one hand is clutching a purse. Then the problem arises: Where do I position the other arm?

But a model isn't always doing a specific action. Generally speaking, she's striking a pose, which may be a caricature of an action, but is still just posing. How do you create an arm pose without making it look too self-conscious or stiff?

The answer is to draw the arm to be somewhat vague in its purpose. Perhaps an arm hangs, elbows bent, by her sides, relaxed. It's hard to make that look wrong, whereas if she were, say, watering a potted plant, her grip on the handle and extension of the arm would draw attention to itself and provoke more scrutiny.

If you're stuck for some ideas on arm poses, here are a few suggestions that can work for you. Give them a try. You can also adjust them, or combine them, to create your own.

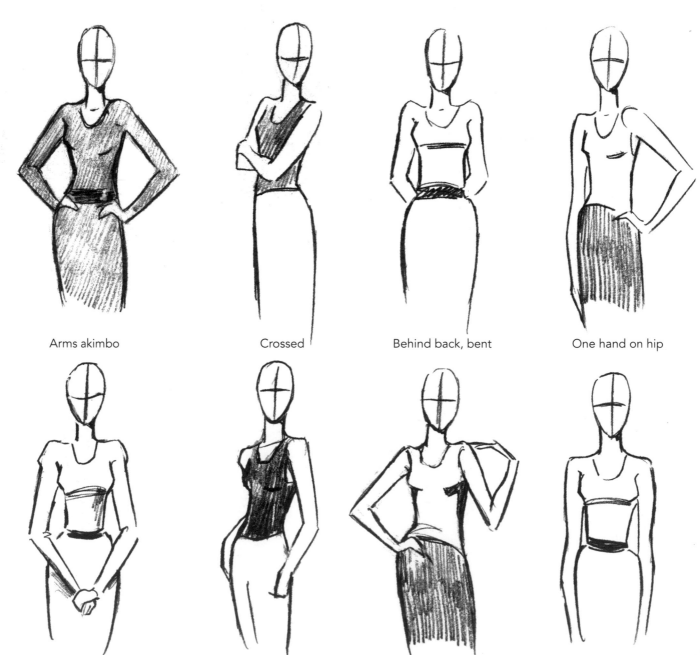

Arms akimbo

Crossed

Behind back, bent

One hand on hip

Clasped hands

In pockets

Reverse symmetry

Hanging at sides

leg **poses**

It can be challenging to come up with a variety of leg poses, because they're not as dexterous as arms. But because legs are an integral part of the posture of a pose, they must be treated as an important aesthetic. Hint: don't overlook the width of the stance in your poses. Stances can be varied, wider or narrower, to create different looks.

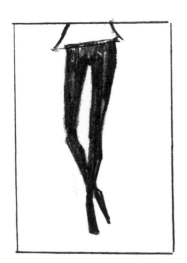

Crossed at calves

Knee in

Outward curving

Leg extension

Knee in with big
tilt of hip

Knee bent out

Knees together

Crossed at knees

drawing **hands**

Despite the fact that there are pockets and mittens, sooner or later, you're going to have to draw the hands. Have no fear: the hands do not need a great deal of detail. And the finger positions should be pleasing, which means that complex hand positions are generally best avoided.

Here are some general pointers to remember when drawing hands:

- Avoid defining the knuckles.
- Limit the creases on the palm.
- Don't draw nails (unless it's a close-up), but taper the fingers.
- The backward bend of the thumb should be minimized.
- Keep the wrist small, gradually leading into the hand; avoid a sudden jump in width.
- Indicate the relative lengths of the fingers.
- The fingers should be lithe and thin, but not bony.

palm and **back**

- The fingers taper at the top.
- There is a wedge of connective tissue between the thumb and index finger.
- This protruding joint, at the base of the thumb, is minimized.
- The guideline for the knuckles is curved.
- The bottom of the palm, on the outside, just above the wrist, slopes inward.
- There is a slight space between the fingers where they attach to the palm. (This is what gives the hands their width.)
- Interior creases of the palm are minimized.

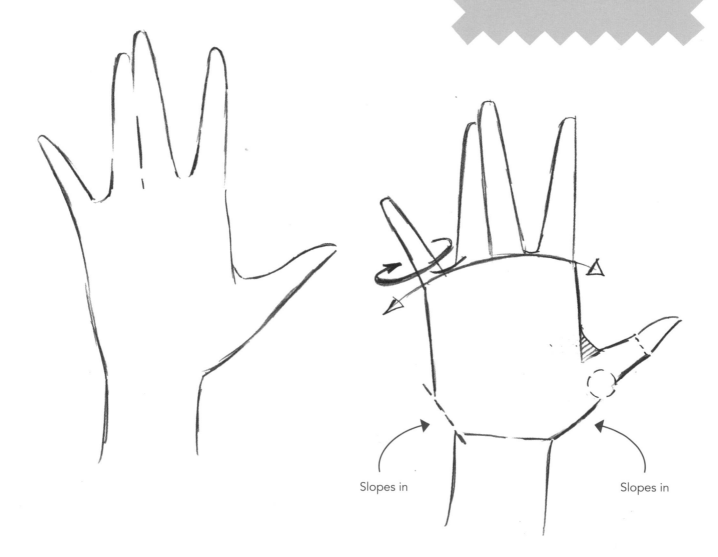

Slopes in Slopes in

28

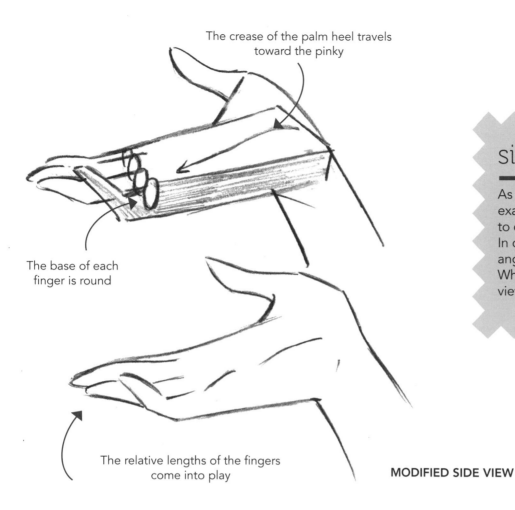

The crease of the palm heel travels toward the pinky

The base of each finger is round

The relative lengths of the fingers come into play

MODIFIED SIDE VIEW

side **view**

As you can see from the top example, it can be more pleasing to draw a "cheat" in the side view. In other words, the hand has been angled slightly toward the viewer. While it still appears to be in a side view, it is not a strict side view.

The wedge area between the thumb and index finger is still in evidence

There's a slight pad under the base of the fingers

The thumb is made up of three joints, just like the fingers. Smooth them out so they do not become too articulated. It's okay if the viewer believes the thumb only has two joints—as long as you know that it has three.

STRICT SIDE VIEW (INSIDE)

29

Use these drawings as reference for practicing drawing the hand in different positions and from a variety of angles.

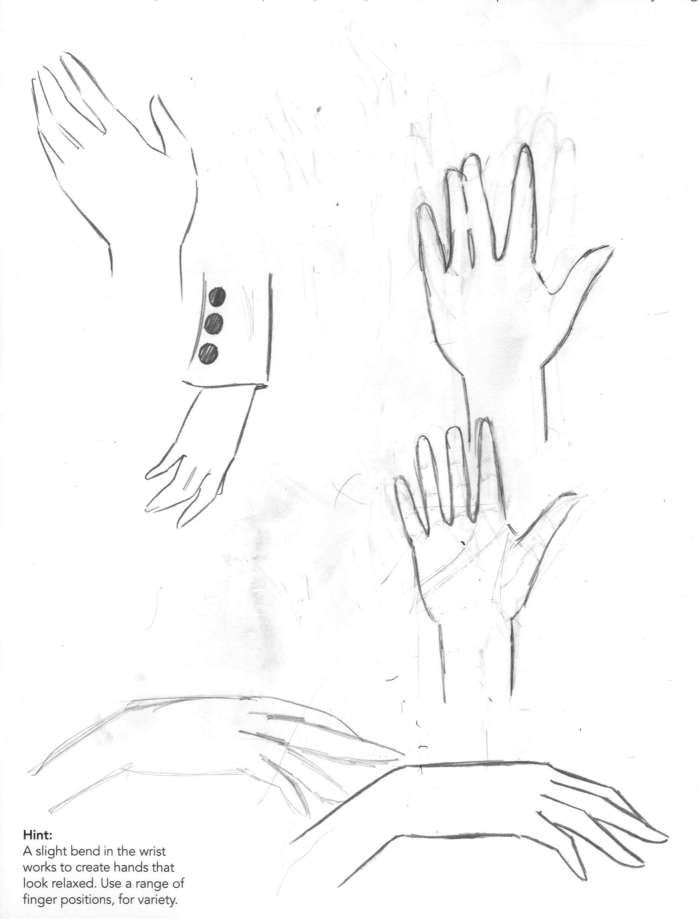

Hint:
A slight bend in the wrist works to create hands that look relaxed. Use a range of finger positions, for variety.

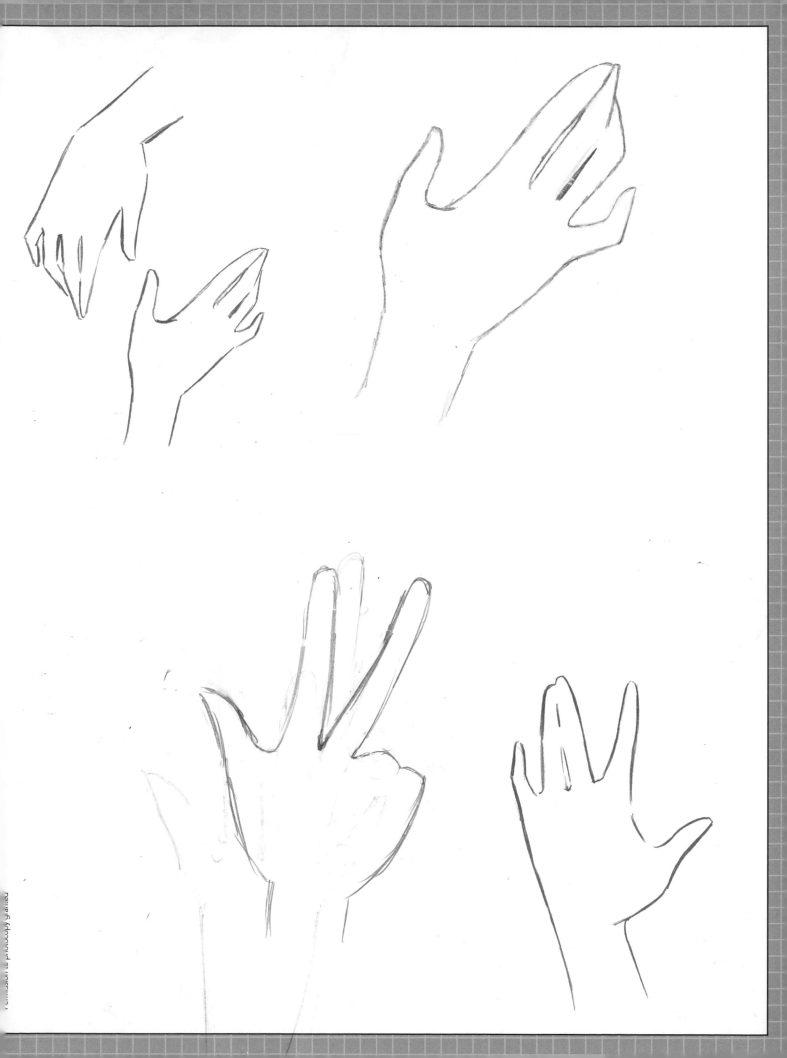

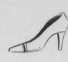
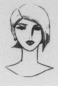

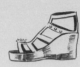

drawing **feet**

Let's do a brief overview of the feet. We'll keep it brief because we have an upcoming section on drawing shoes, which will cover much of the same material, but with a somewhat different approach.

Unlike fingers, toes are more appealing if they are drawn together rather than varying their positions.

Bottom

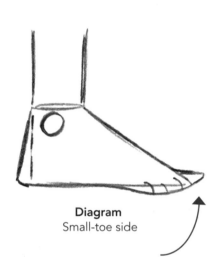

Diagram
Small-toe side

Diagram
Big-toe side

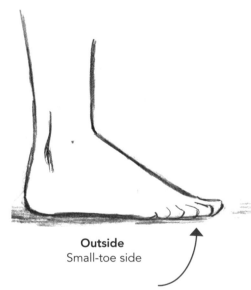

Outside
Small-toe side

Inside
Big-toe side

Top

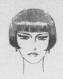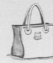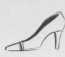

front view—
foreshortened

There are several ways of showing a foot in the front view. The first way is correct, as it foreshortens (flattens out) the foot. A more appealing approach is to draw the foot with a higher bridge, so that it doesn't appear too squat. The most appealing look is to point the toe slightly away.

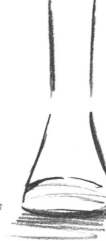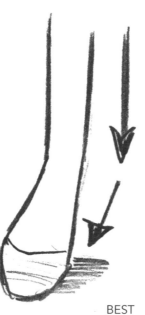

OKAY
Foreshortened

BETTER
Foreshortened with
raised bridge of foot

BEST
Toes pointed

Extending the foot makes the line of the leg appear longer, which is a sleek look.

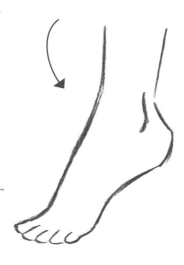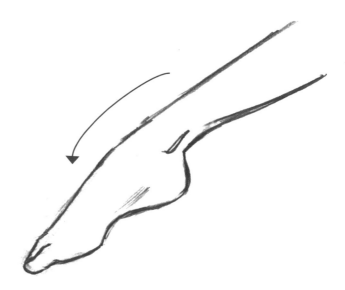

the fashion face

Most aspiring artists put at least equal emphasis on the head and the body. But with fashion illustration, we don't want the face to compete with the clothing for attention. Too much detail will do that. So our goal is to draw the face with as little definition as possible, while maximizing attractiveness and style.

Here are a few more common mistakes that cause the face to attract undue attention, stealing the show from the outfit. Being aware of these pitfalls will help you to easily avoid making them:

- The hairstyle is the boldest aspect of the drawing.
- The hair color is bizarre.
- The character has an odd or unusual expression.
- The angle of the head is unclear.
- The eyes are too big.
- The model appears to be talking.
- The face is highlighted with dramatic shadows.

the shape **of the head**

Sometimes aspiring artists, eager to draw the eyes, nose, and mouth, give short shrift to the shape of the head. While this is understandable, it's not desirable. The outline of the head is as important as the features of the face. If the head shape is drawn sloppily, the features may appear to wander. And, even more important, unless the head is based on a solid shape, it's not possible to draw the character in a variety of angles.

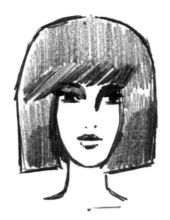

Oval Tapered oval

adjusting the **head shape**

Although a tapered oval is a great foundation, one cookie-cutter shape does not fit every head. Allow yourself the freedom to add mass to the cheekbones, chin, or jaw; or, alternatively, to carve away at some areas.

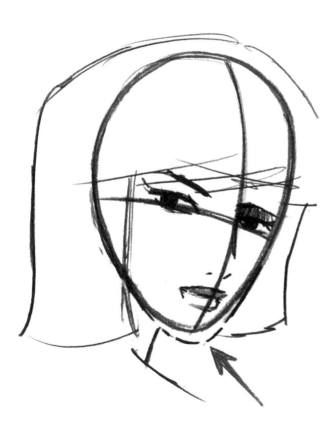

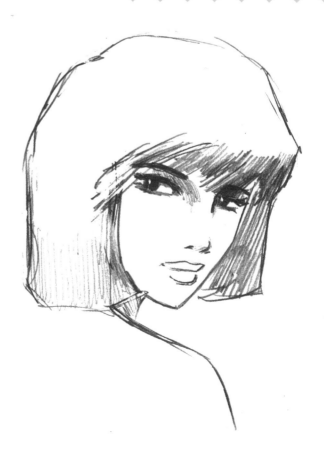

With the basic head shape in place, we begin to make small adjustments to create individual people. On this female model, the chin is slightly elongated to give the face a sleeker and more dramatic look.

 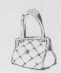

head **turns & tilts**

The head turns at left or right angles, or tilts up and down. It can also be drawn by combining angles; for example, a left-facing, downward tilt of the head. The only way to maintain a consistent look in a variety of angles and tilts is to use a basic shape for the head, with guidelines on which to hang the features. These guidelines are called the "center line," which goes up and down the middle of the face, bisecting it equally in two parts; and the "eye line," which is a horizontal line that goes about halfway up the head, and on which the eyes are drawn. The "X," where the center line and the eye line meet, is where the bridge of the nose is drawn.

Note that the center line is straight in a front view, but takes on a curved look as the head begins to turn left or right. If the face turns page-right, the center line will curve outward to the right. If the face turns page-left, the center line will curve outward to the left. This curving of the center line makes the head appear round, and sets up the correct placement of the features.

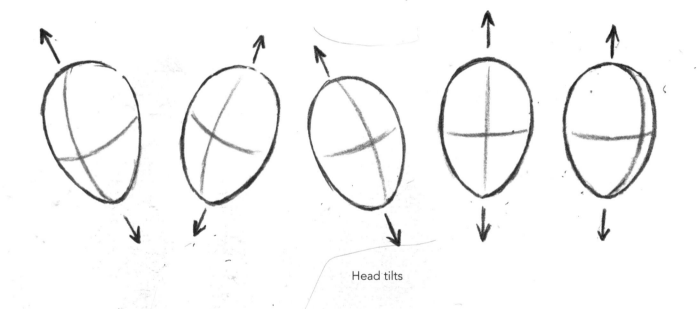

Head tilts

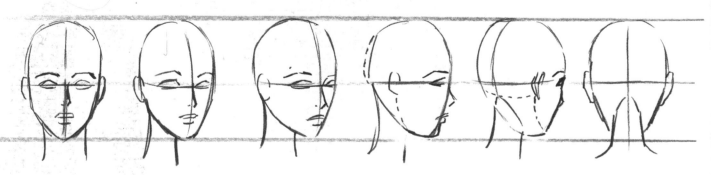

Head turns at various angles

draw it yourself: head tilts—up

Use the drawings below and on page 38 as reference for practicing drawing heads tilted up or down. When the head tilts down, the eye line is drawn curving up. When the head tilts up, the eye line is drawn curving down. The ears are placed slightly higher on a downward tilt and slightly lower on an upward tilt.

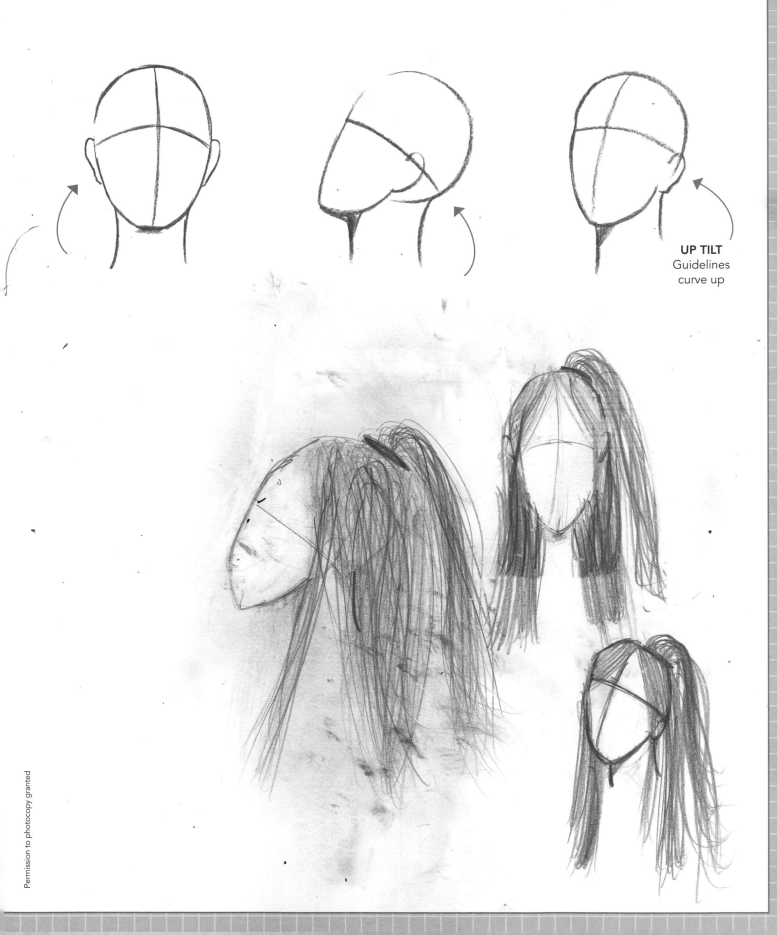

UP TILT
Guidelines
curve up

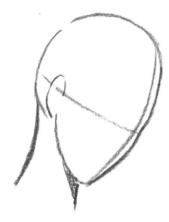

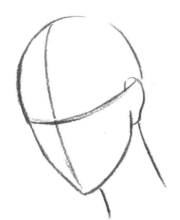

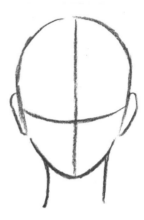

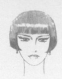
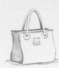

the features **of the face**

The features on fashion models are drawn as if they have makeup applied. This can elongate the look of the eyes, thicken the eyelids, or make the lips appear curvier. We're adding glamour right from the start, incorporating it into the basic features. In other genres of illustration, style is considered to be secondary to the basic drawing. But in fashion illustration, style is one of the essentials. Even the basic proportions of illustrated fashion models are altered to give them a glamorous look (as we've seen in earlier chapters).

drawing the **eyes**

Eyes are spaced a single eye-length apart. Tilt them slightly upward at the ends, for a stylish look. To underscore this effect, draw the eyelashes sweeping upward and outward at the ends.

The top of the eyelid rests on the iris, and even touches the pupil. The eyeball is darkest just below the upper eyelid. If you add an eye-shine, do it in the darkest corner of the eyeball, so that it stands out. You can also add a small, reflective eye shine at the bottom. But remember we said that we don't want to attract too much attention to the head, and away from the outfit. Therefore, be moderate in your use of eye shading and shadow, if you choose to use it at all.

Eyebrows vary in thickness, widening as they travel toward the bridge of the nose. Arch them, and give them a slightly sharper angle downward at the insides. They should be dark, or they will cause the eyes themselves to look weak.

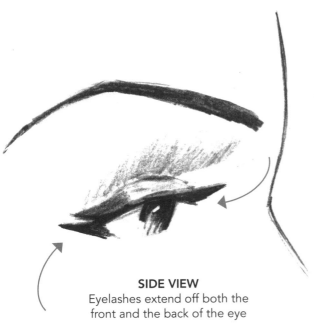

SIDE VIEW
Eyelashes extend off both the front and the back of the eye

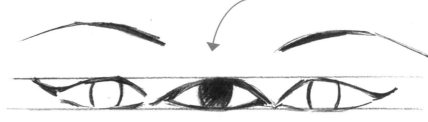

The eyes are spaced a single eye-length apart

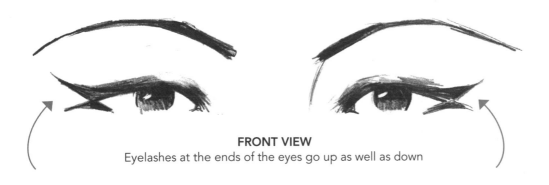

FRONT VIEW
Eyelashes at the ends of the eyes go up as well as down

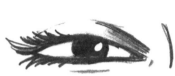

> The closer the image, the more detail is required. And with added detail, you have the opportunity to give a specific look or personality to the eyes.

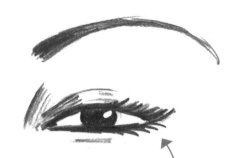

SEMI-SQUINT
Usually on a cheerful expression

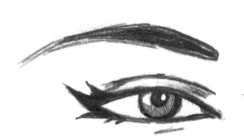

EYELASHES BUNCHED
Gives them a thicker look

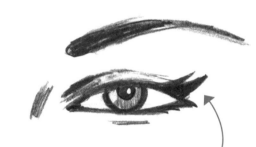

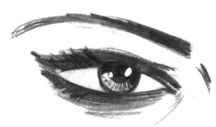

DEEP EYES
Notice the markup underneath the eyes

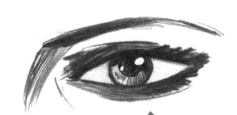

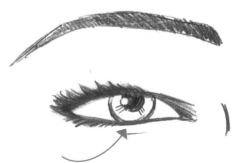
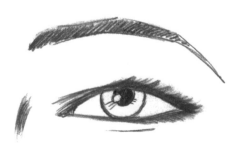

HOPEFUL EYES
Note the thinly drawn irises, which are empty of shading

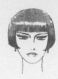 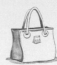 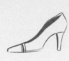

the eyes **in color**

No one can tell you how to apply makeup to the eyes. It's as individual a process as it is when a person applies it in reality. But however you choose to represent makeup in your drawings, it's best to work in stages, as shown here.

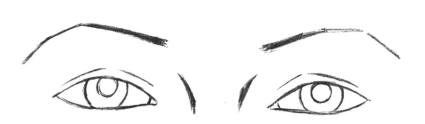

1. No color.

 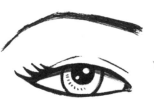 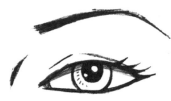

4. Blacken the pupils around the highlights. Add a few light markings for the interior of the iris. Add subtle shading to the eyeball just under the upper eyelid. With that in place, add color to the upper eyelids, and just a suggestion of color to the lower ones.

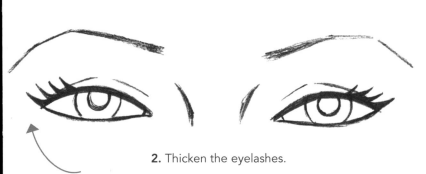

2. Thicken the eyelashes.

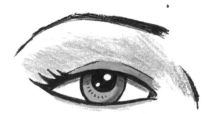 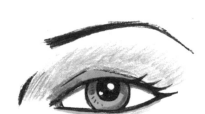

5. To finish up: add a little shading to the iris with a darker tone of the same color (e.g., darker green shading onto a green iris). Shade the outer parts of the eyelids. Finally, add some color to the deep pockets under the eyebrows.

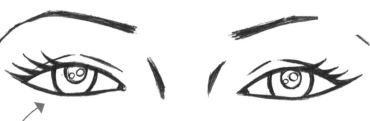

3. Thicken the outlines of the iris and pupils. Add unequal shines to the eyes, diagonal to each other. Now add color to the iris.

41

draw it yourself: eyes

The blue line images are your basic construction, to get you started. Go over the blue lines with a dark pencil or pen, adding the necessary detail. Darken in the areas that need it, like shadows and blacks. If working with color, add it once the drawing is completed. The spaces between the blue line images are for drawing your own eyes and makeup looks.

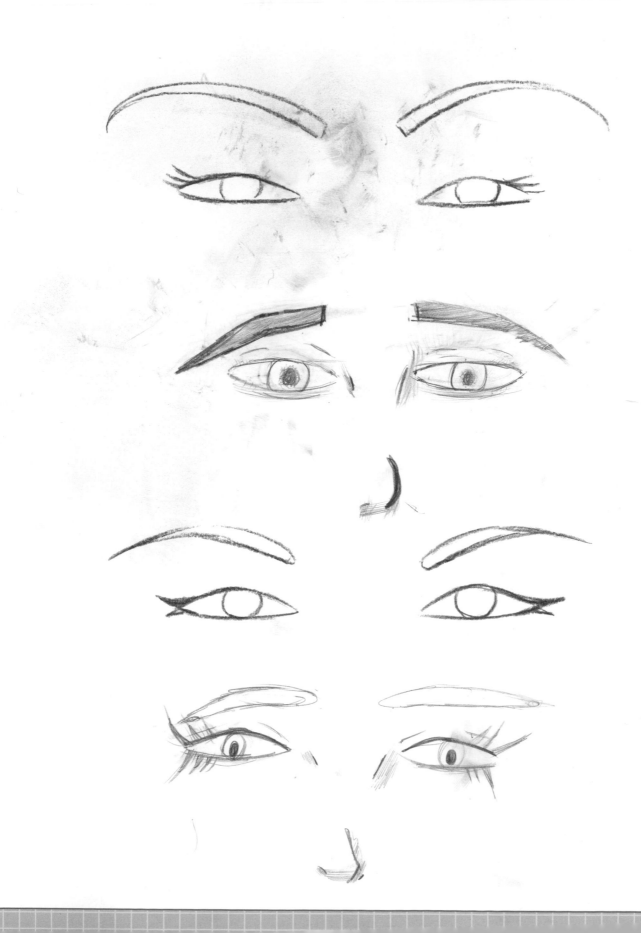

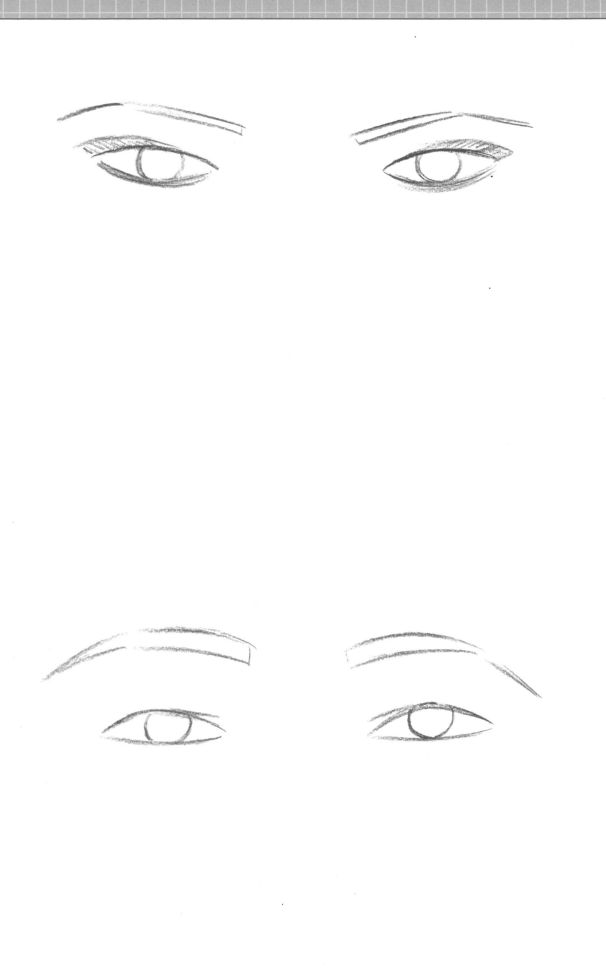

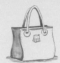

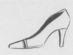

drawing **the nose**

In the front view, the nose is generally minimized, created with as few lines as possible. This is in keeping with the look of fashion illustration. Therefore, not all the lines of the nose are, or should be, connected. The bridge of the nose is minimized or even omitted, and the nostrils are barely noticeable.

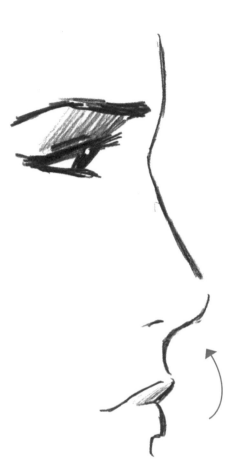

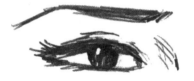

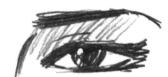

Only the bottom of the nostrils— the holes—are suggested; the covers are omitted

The line that forms the bridge of the nose is not continuous

In the profile, the tip of the nose turns upward ever so slightly

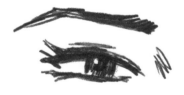

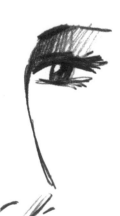

A slight shadow under the tip of the nose helps give it dimension

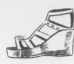

the **lips**

It's usually easier for artists to draw the lips by first indicating a single line for the mouth. Once that's done, indicate top and bottom lips.

details

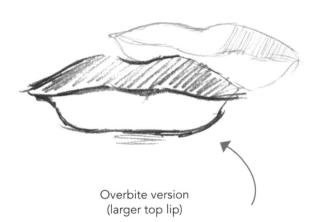

Overbite version
(larger top lip)

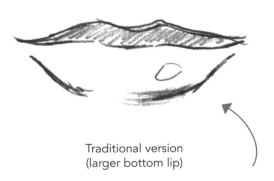

Traditional version
(larger bottom lip)

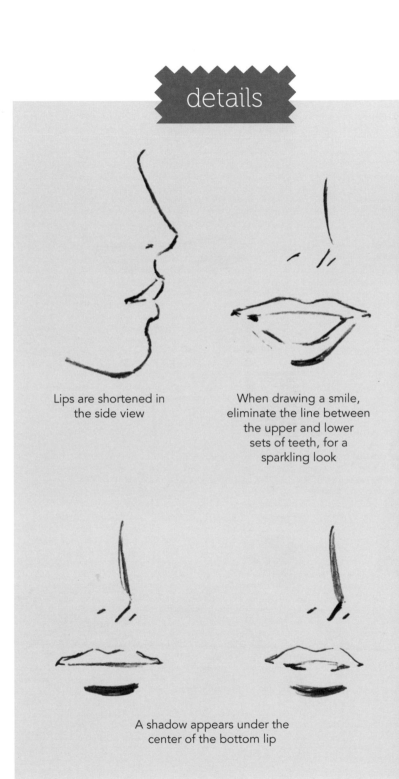

Lips are shortened in the side view

When drawing a smile, eliminate the line between the upper and lower sets of teeth, for a sparkling look

A shadow appears under the center of the bottom lip

45

hair **dos & don'ts**

Start at the top of the head, always making sure to leave extra height at the top to give your look dimension.

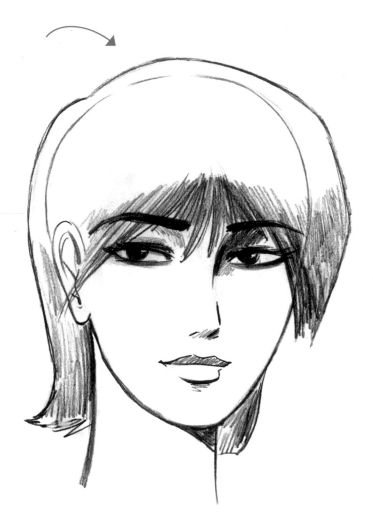

classic **styles**

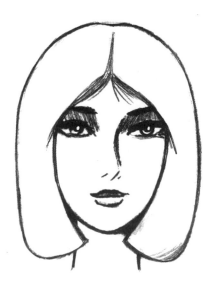

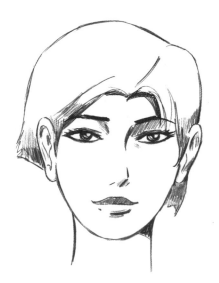

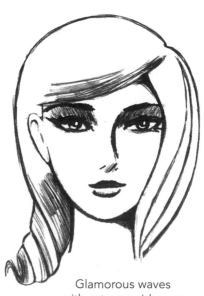

Straight, chin-length with center part

Short, straight, and asymmetrical with side part

Glamorous waves with extreme side part

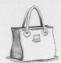

adding **hair**

It's recommended to begin with the complete outline of the head. Keep the outline until you've finished drawing the hair.

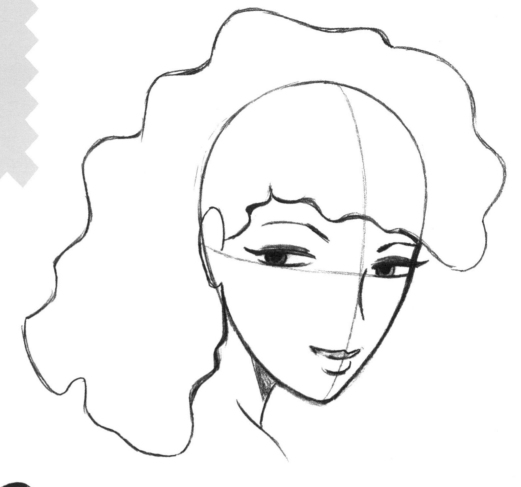

Remember: hair—especially curly, wavy, thick, or textured hair—always has volume, which, in turn, creates height and width.

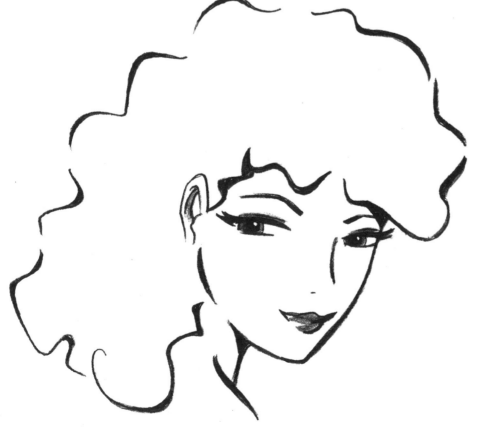

haircuts **& styles**

Few decisions make as great an impact on the overall look of a character as the hairstyle. And that's because you can give your fashion model the most expensive cut there is, and it won't cost you a dime! The cut works best if it reflects the choice of clothing. For example, you wouldn't normally draw an avant-garde haircut on a model wearing a conservative outfit.

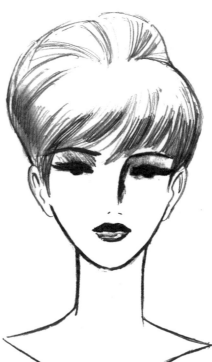

SIDE PART

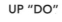

UP "DO"

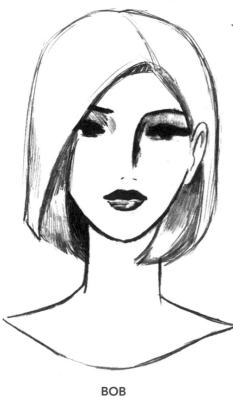

BOB

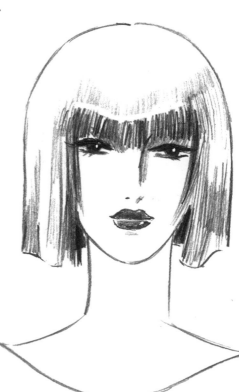

BOB WITH BANGS

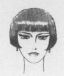 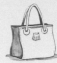 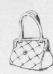

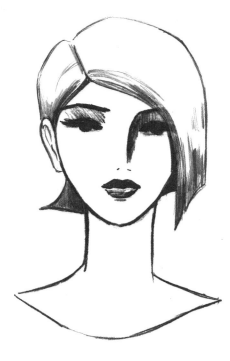

SHORT SIDE BOB

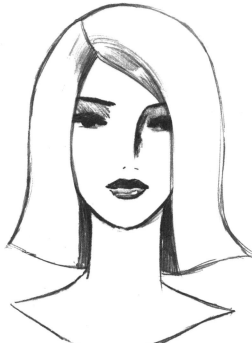

LONGER BOB

Below, I've listed some hairstyle elements you can use and combine to come up with appealing, stylish cuts.

- Bangs
- Over or behind ears
- Length
- Direction
- Line flow
- Part
- Soft-looking hair versus a sharp cut
- Braids and ponytails
- Flip
- Buns
- Choppy
- Up or down
- Curls, straight, or wavy
- Strands

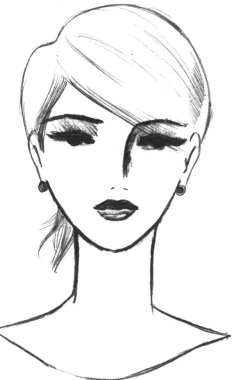

SHORT CUT

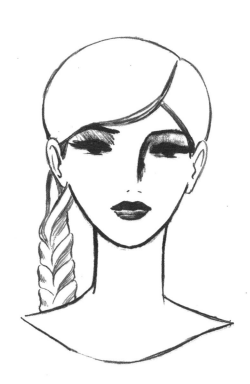

BRAID

49

 draw it yourself: hairstyles

Use the heads on these pages to experiment with hairstyles and lengths.

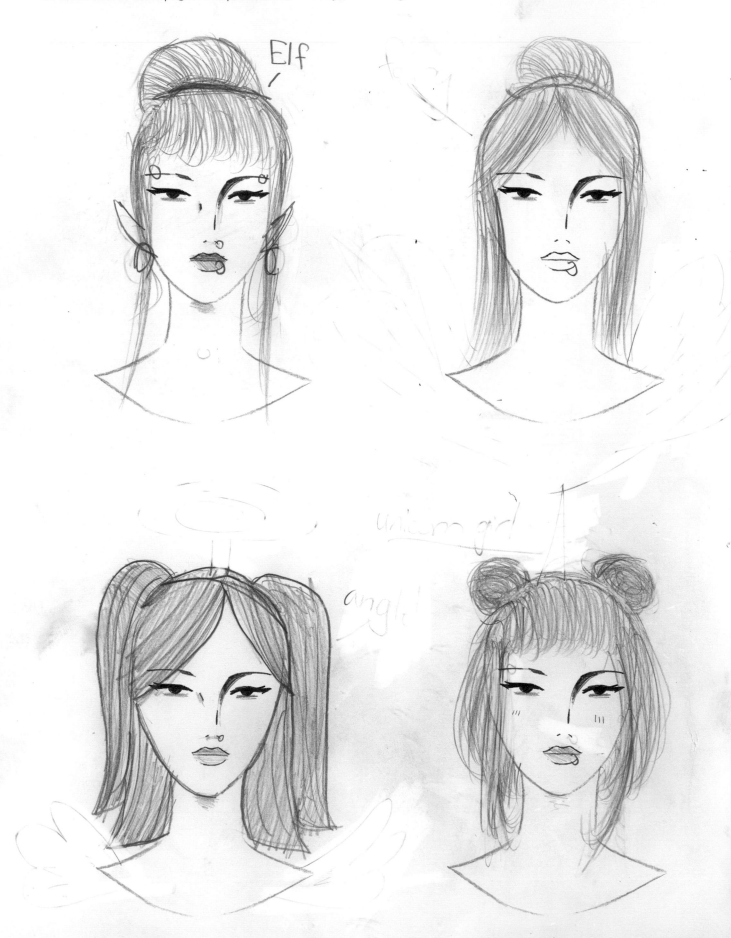

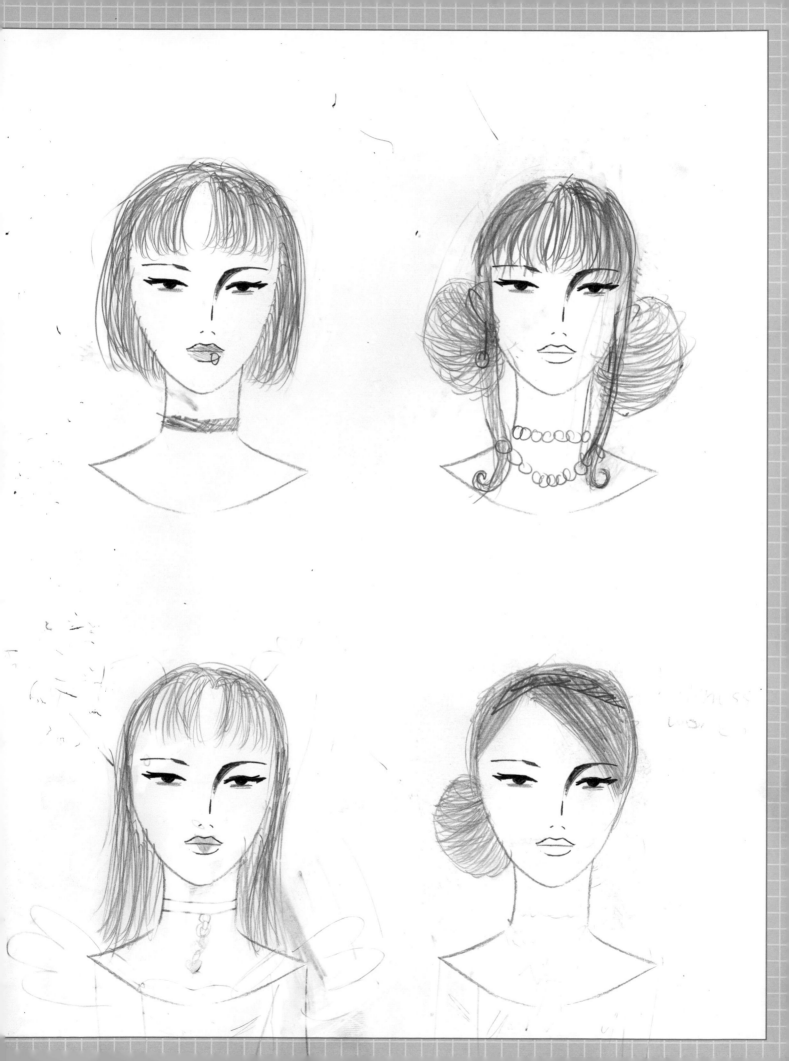

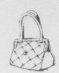
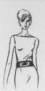

the head—**step-by-step**

Now let's draw the complete head from start to finish, including the hairstyle. We'll start off by practicing some front views, and work our way up to drawing the head at a few different angles. You'll notice that we work in stages, rather than finishing each feature as we go along. First we sketch in the features for placement, and worry about refining them later, once they are all in place. Expect to do some erasing. No one gets everything right the first time. Erasing is not a negative. It's part of the creative process as you explore all of your options. Once everything is in place, and you like how it looks, go back and finish the details.

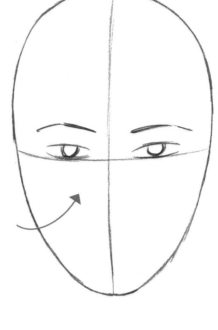

2. Draw the eyes on top of the horizontal eye line. Check to make sure that each eye is equidistant from the center line, in order to keep them evenly placed on the face.

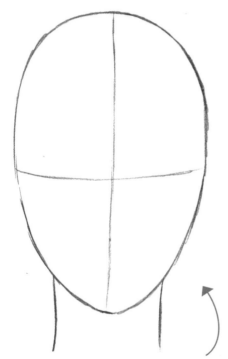

1. Tapered oval for the head shape—guidelines sketched in lightly.

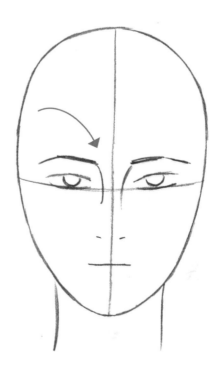

3. Lightly indicate the bridge of the nose, and the end of the nose. Draw a line for the placement of the mouth.

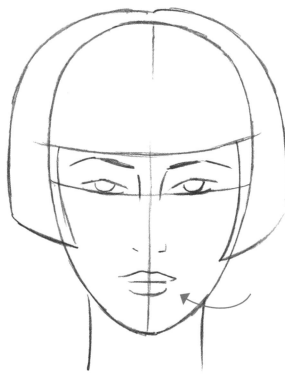

4. Add full lips, and create an outline for the hair, which widens and appears to have more body as it travels downward from the top of the head.

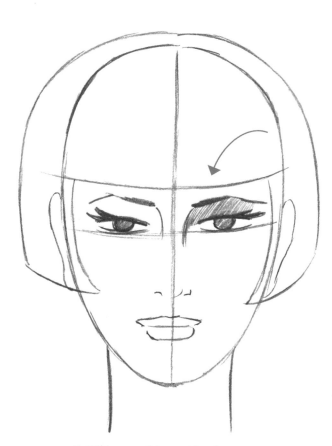

5. With everything set in place, now is the time to work the details, such as the eyes and shading. Vary the tones to create interest.

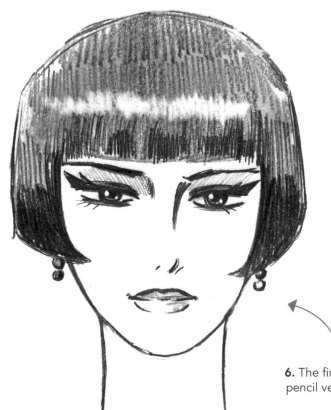

6. The finished pencil version.

53

3/4 view—**step-by-step**

Turn the face slightly from a front view, and you've got a three-quarter view. At this angle, the bridge of the nose helps to define the angle of the face. Note the slightly protruding cheekbone on the far side of the face, just below the eye.

left

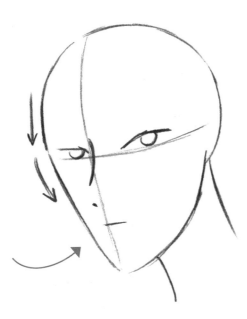

1. The outline tapers toward the chin.

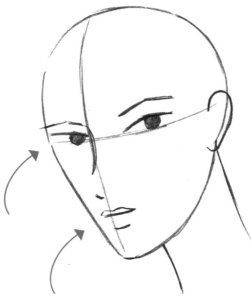

2. In a three-quarter view, the lips are slightly shortened, as is the far eye.

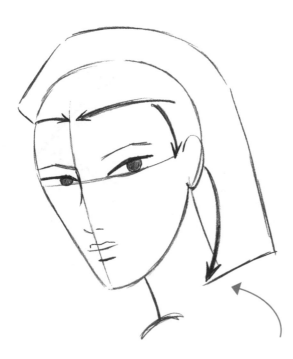

3. Add bold, sweeping lines to the basic look of the haircut.

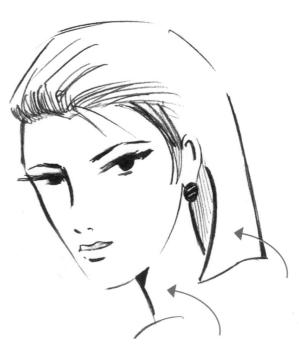

4. Finished pencil drawing. Note that the thickness of the line differs throughout the drawing, with the bolder parts drawn in a thicker line.

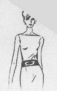

right

Showing the hair behind the face, as well as in front of it, is a nice look. But limit the amount of hair that you can see behind the face. If you show too much, it has the effect of flattening out the image. It's a nice look to draw the three-quarter view, while the eyes glance in the opposite direction that the head is facing, as shown here.

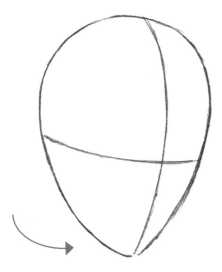

1. Tapered chin in the basic construction of the head.

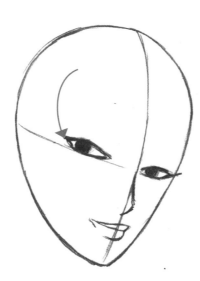

2. Add the features. Note the eyes glancing back.

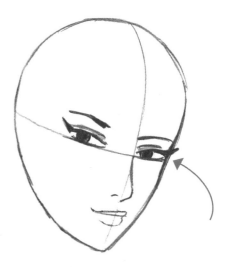

3. Slight indentation at the orbit of the eye.

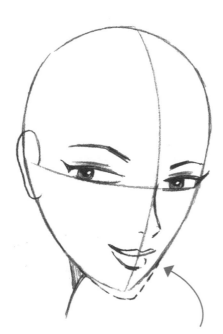

4. Note the construction of the lips as they appear in a three-quarter view.

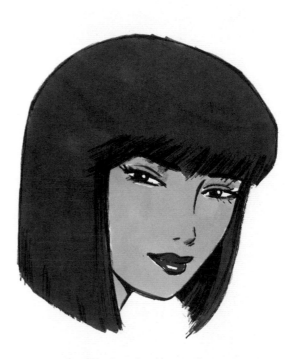

5. Completed color rough.

profile—
step-by-step

Ah, yes, we come to the profile, that trickiest of all the easy-looking angles. It looks so simple. After all, you only have to draw one of everything: one eye, one nostril, one eyebrow, and one ear. The reason it's challenging is because the outline of the front of the face is very specific. If you're off by a little, it can appear off by a lot. The mistake made by some beginners is not adding enough curves to the outline. But if we examine the head construction carefully, we'll see that the side view is all about curves.

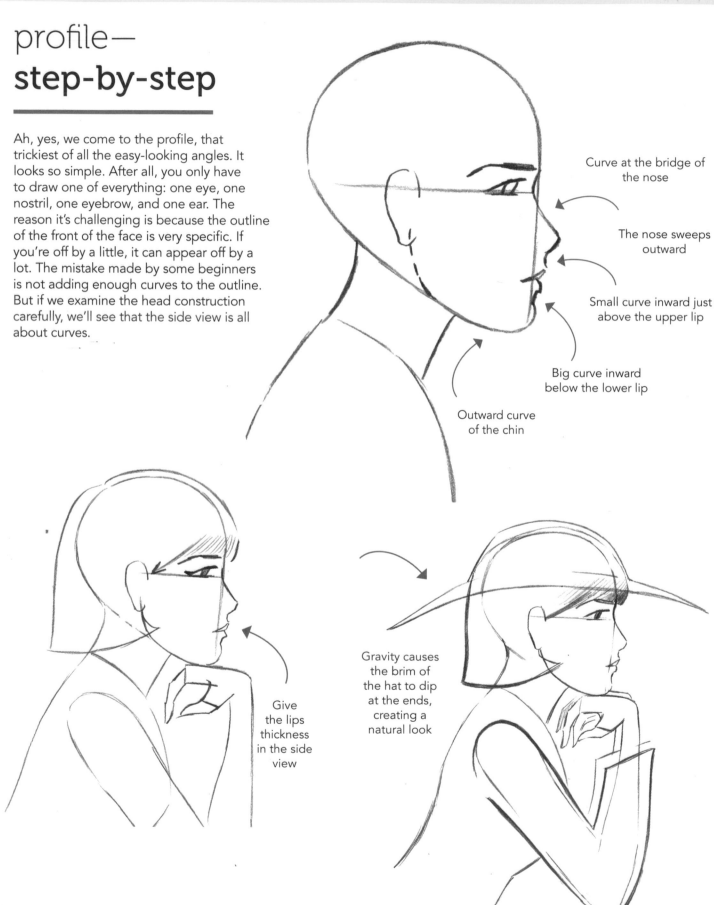

Curve at the bridge of the nose

The nose sweeps outward

Small curve inward just above the upper lip

Big curve inward below the lower lip

Outward curve of the chin

Give the lips thickness in the side view

Gravity causes the brim of the hat to dip at the ends, creating a natural look

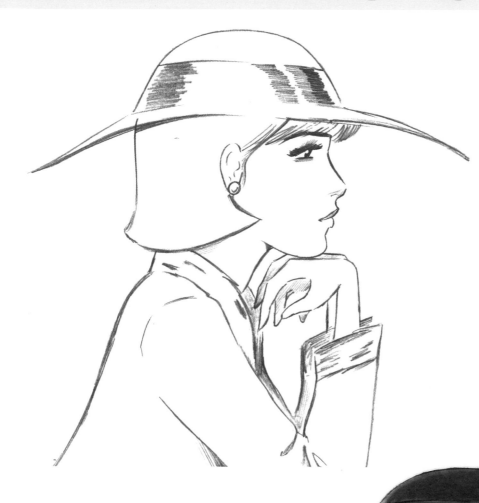

It helps to draw a little more of the character than will be shown in the actual finished piece. For example, this sketch originally contained more of the body. This helped in achieving a natural look.

In the final drawing, we can "crop" the image further by omitting color from the bottom, thereby focusing the viewer's eye on the most important elements: the head and hat.

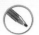

draw it yourself: the head—front view

Use the blue line images below and on the following pages as templates for drawing unique hair and makeup looks on a figure.

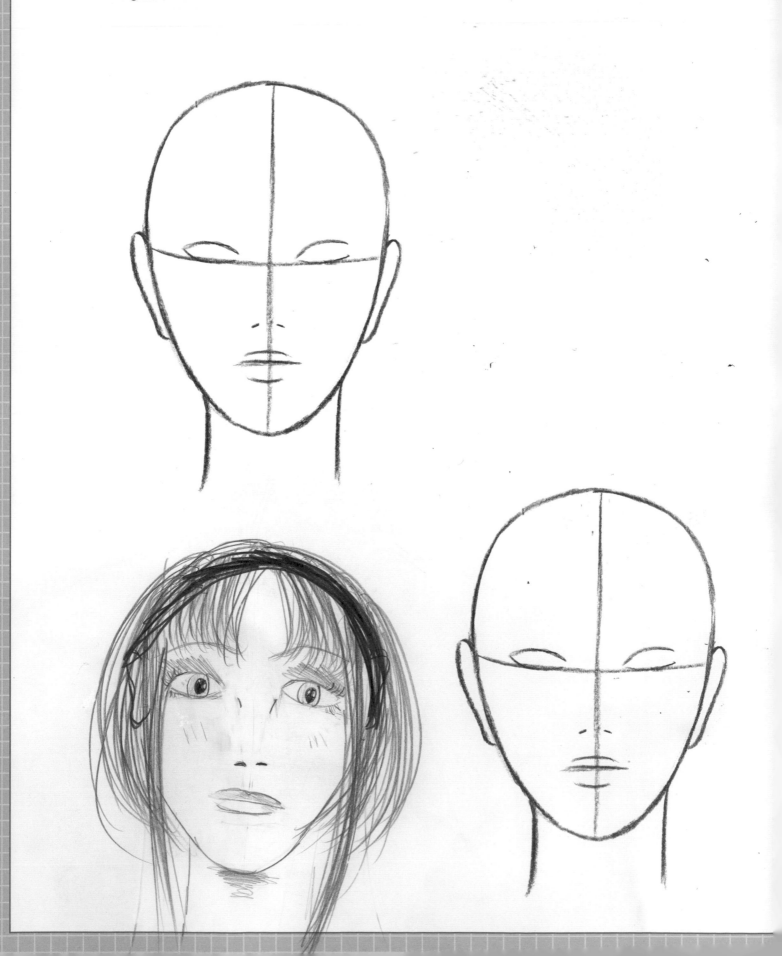

three-quarter view, left

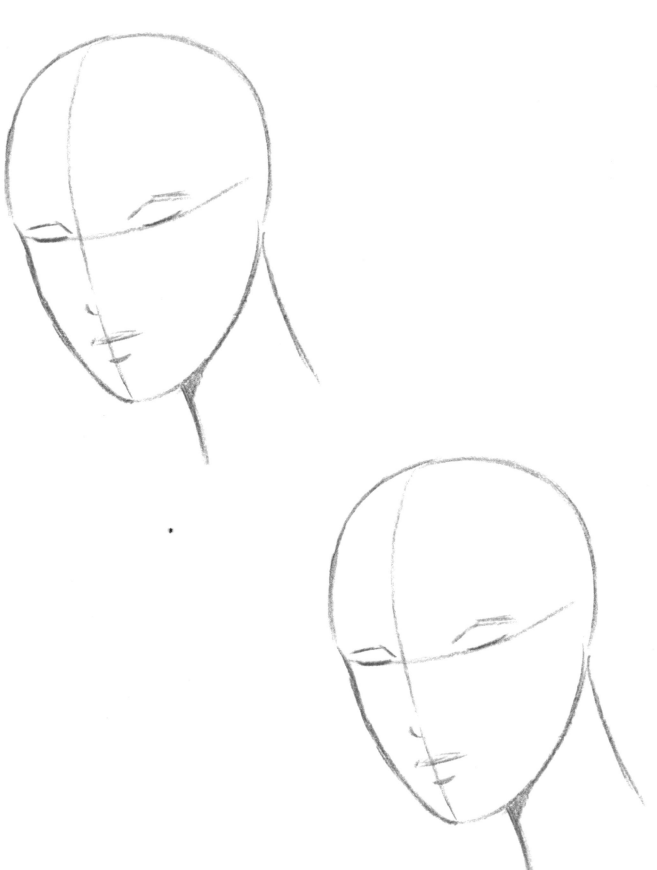

three-quarter view, right

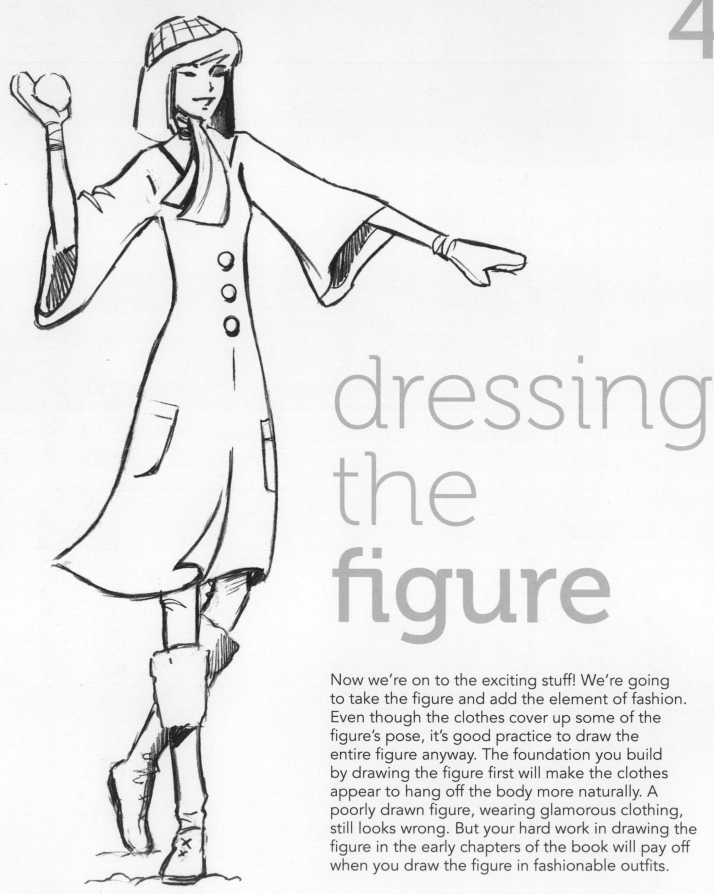

4

dressing the figure

Now we're on to the exciting stuff! We're going to take the figure and add the element of fashion. Even though the clothes cover up some of the figure's pose, it's good practice to draw the entire figure anyway. The foundation you build by drawing the figure first will make the clothes appear to hang off the body more naturally. A poorly drawn figure, wearing glamorous clothing, still looks wrong. But your hard work in drawing the figure in the early chapters of the book will pay off when you draw the figure in fashionable outfits.

clothing on **the figure**

Whether you're drawing sleeves, a hem, or pant cuffs, clothing is cut at specific lengths. The more decisive you can be in defining the length, the more recognizable the style will be to the viewer. Clothing adds bulk to the figure, not just from the material itself, but from the space between the material and the skin. Some pieces of clothing, like the collar, overlap other pieces, making that part thicker. Shoulders typically add a degree of firmness, or construction, to clothing. Vary the spacing between the clothes and skin at various points where indicated, such as the waistline.

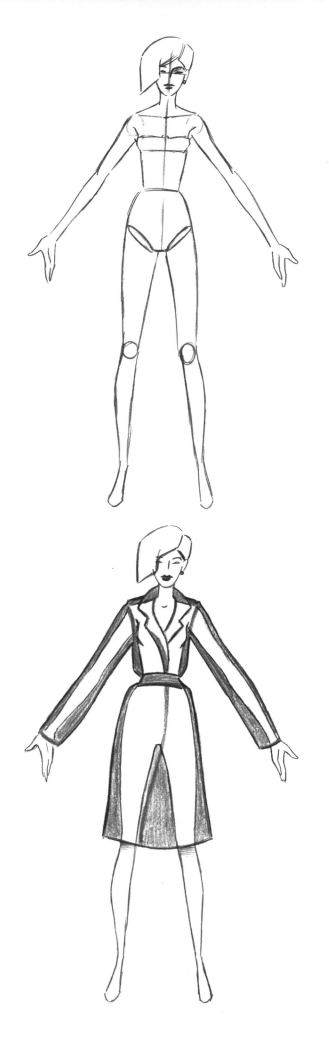

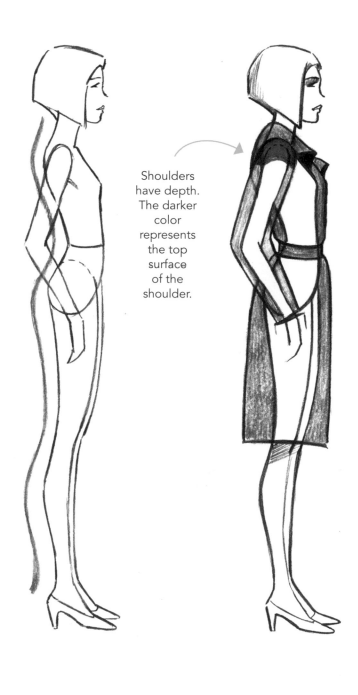

Shoulders have depth. The darker color represents the top surface of the shoulder.

curves, **collars, & sleeves**

Collars, waistbands, and sleeves are generally drawn as ovals. The direction of the curves should be consistent with the vantage point of the viewer. In this case, both sleeves curve away from the viewer. Being consistent in this manner helps to create a three-dimensional look.

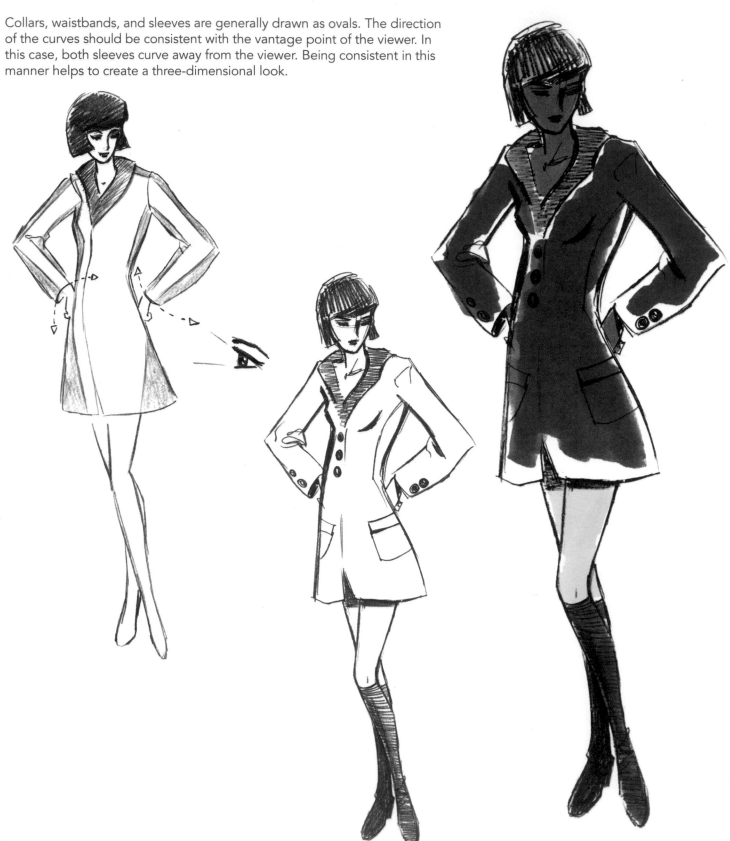

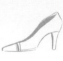

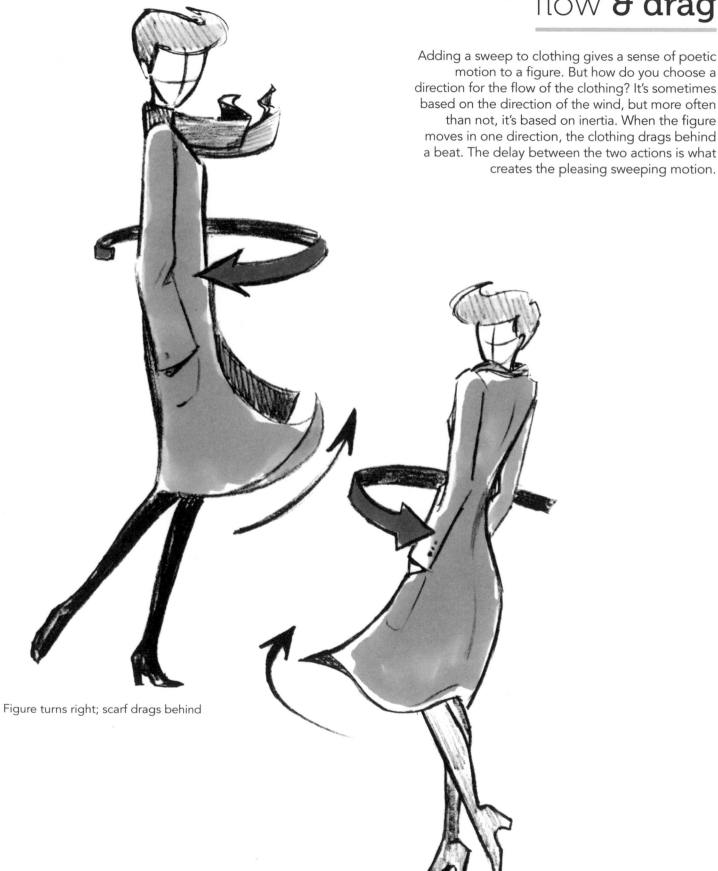

flow & drag

Adding a sweep to clothing gives a sense of poetic motion to a figure. But how do you choose a direction for the flow of the clothing? It's sometimes based on the direction of the wind, but more often than not, it's based on inertia. When the figure moves in one direction, the clothing drags behind a beat. The delay between the two actions is what creates the pleasing sweeping motion.

Figure turns right; scarf drags behind

Figure turns left; coat drags behind

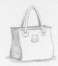

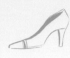

inside/**outside**

Along with an eye-catching sweep to such flapping articles of clothing as scarves, jackets, dresses, and capes, we'll add one more element: interiors. When a piece of clothing billows, the interior or underside is often visible. Not every image will afford you the option to draw the underside of a garment, but when the opportunity presents itself, I recommend that you capitalize on it, because it adds depth and a touch of flair.

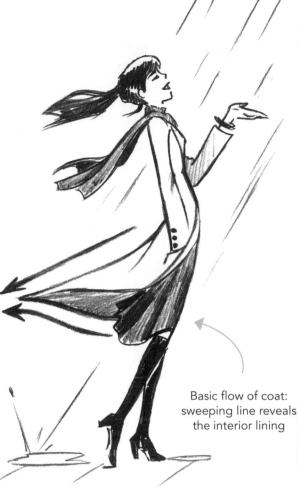

Basic flow of coat: sweeping line reveals the interior lining

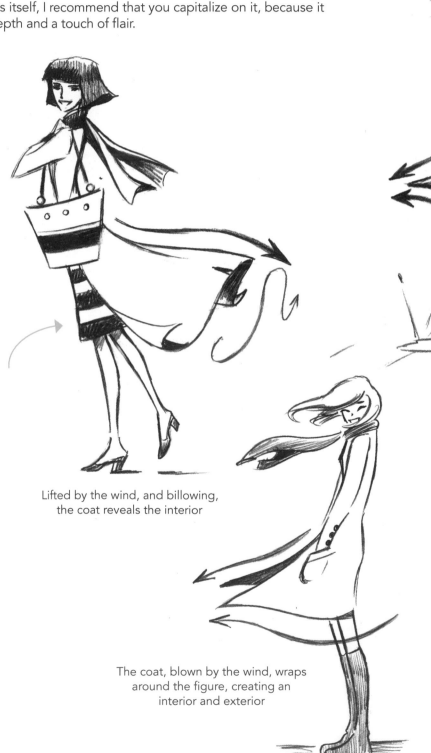

Lifted by the wind, and billowing, the coat reveals the interior

The coat, blown by the wind, wraps around the figure, creating an interior and exterior

creases & folds

Let's take the mystery out of a topic that many find confusing. Although folds have a random quality to them, they also tend to fall into certain patterns that we can identify and label. Being able to draw folds and creases greatly enhances one's ability to represent clothes realistically. Drawing folds takes practice. Don't shy away from it. With practice comes discovery, and then confidence.

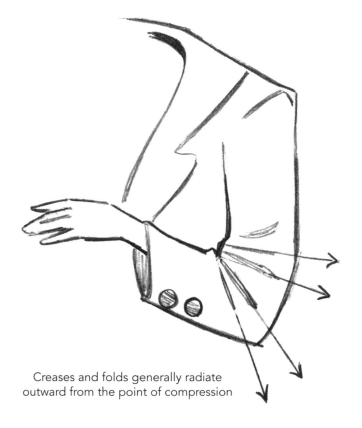

Creases and folds generally radiate outward from the point of compression

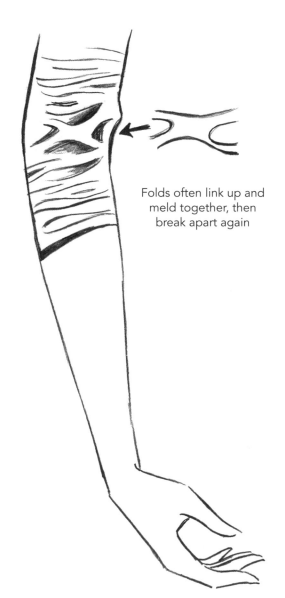

Folds often link up and meld together, then break apart again

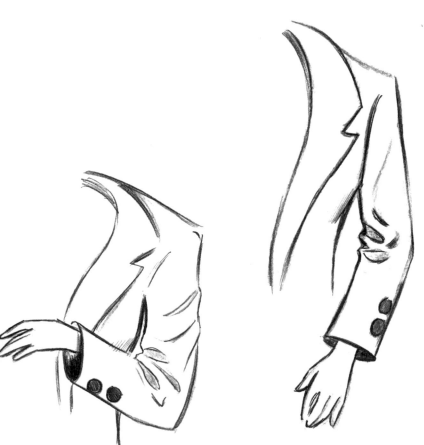

The compression creates little pockets in the creases

67

 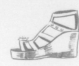 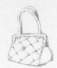

pants

Folds on pants generally occur at the bottom of the legs, where the material gathers, and where there's a lot of stress—such as at the crotch and the knees.

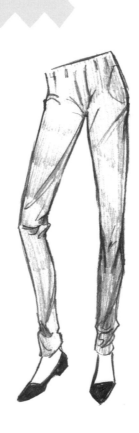

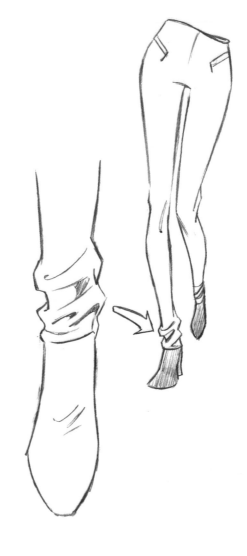

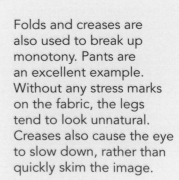

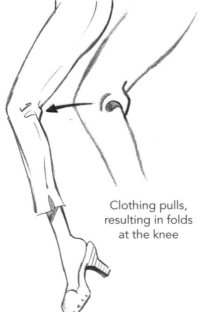

Applied judiciously, folds and creases do not detract from the aesthetics of the clothing

Clothing pulls, resulting in folds at the knee

Folds and creases are also used to break up monotony. Pants are an excellent example. Without any stress marks on the fabric, the legs tend to look unnatural. Creases also cause the eye to slow down, rather than quickly skim the image.

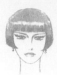 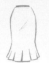 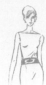

back-&-forth
folds

Some folds swing back and forth diagonally. Hanging drapery does this, but so do folds that run across the body. These folds are especially pronounced when the fabric is either twisted, tight, compressed, or tapers quickly.

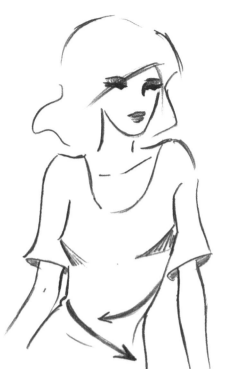

These back-and-forth folds can, when grouped tightly together, create an elegant design, such as the one that appears on this oversized cowl collar. Note how it contrasts with the fairly crease-free sweater below it. Contrast isn't always abrupt; sometimes it's pleasing.

The body of this sweater has a diagonal crease. Does it need one? Not necessarily. However, folds are also added for aesthetics, not just to represent an effect on clothing.

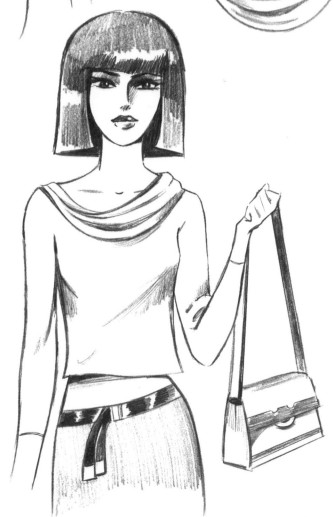

 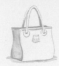

flounces, ruffles, **& all that jazz**

Drawing ruffles can take a lot of time and concentration. However, there are a few techniques we can use to make them simpler—and easier—to draw. Not every ruffle needs to completely fold over itself. Some, like the ones on this page, have varying degrees of fold-over. The smaller the fold-over, the less pronounced the ruffle and the easier it is to draw.

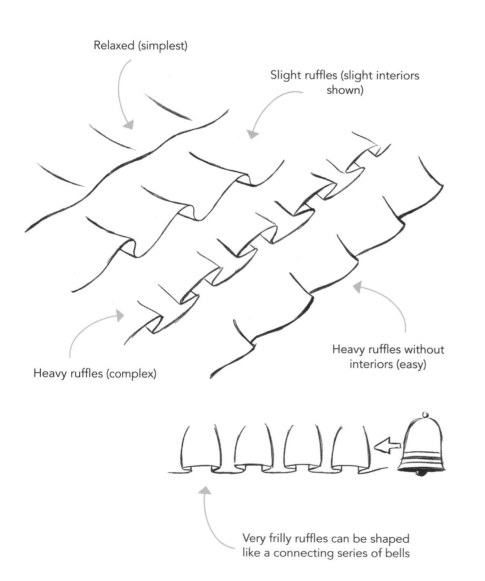

Relaxed (simplest)

Slight ruffles (slight interiors shown)

Heavy ruffles (complex)

Heavy ruffles without interiors (easy)

Very frilly ruffles can be shaped like a connecting series of bells

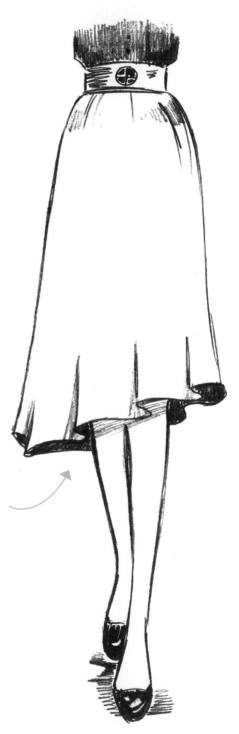

It's not necessary to show the partial undersides of each ruffle, as long as they have striations or appear to overlap to some degree

drawing the figure—
from start to finish

Let's apply some of our hard-won knowledge about drawing the clothed figure on several practice models. We'll go from start to finish, beginning with the basic construction of the figure and ending with models in appealing fashions and poses.

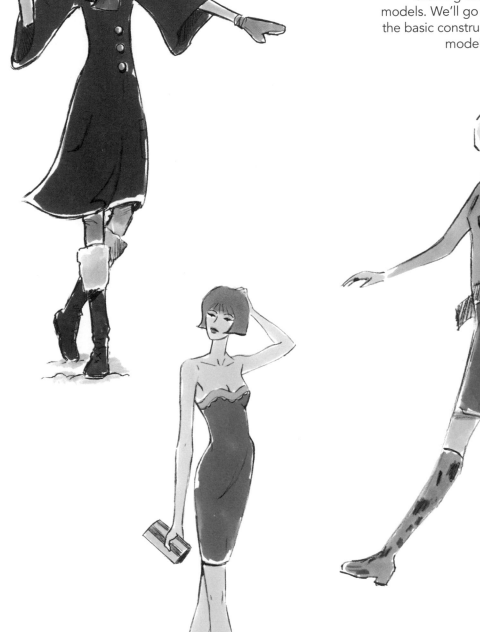

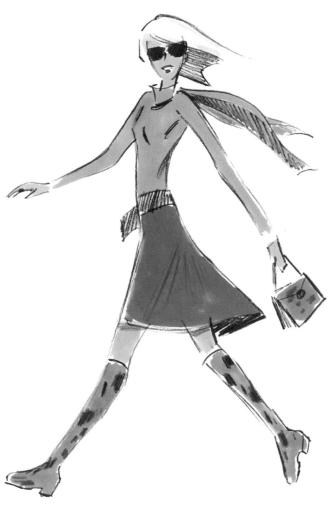

playful **pose**

Although it appears we're drawing an action pose, what we're doing is lending an action to a fashion pose. In other words, the action is secondary to the importance of showing off the clothes in their best light. Therefore, the theme of this image is "having fun," not "throwing."

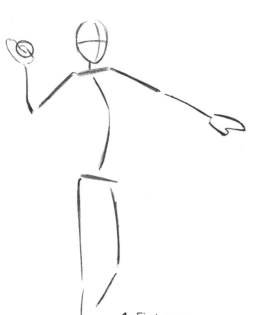

1. First, map out the basic position.

2. Build a solid foundation for our model (note the important shoulder-hip tilt!).

3. With the figure in place, add the coat, which appears to be in motion, reflecting the action.

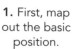

4. The openings of the sleeves are represented by ovals, not circles.

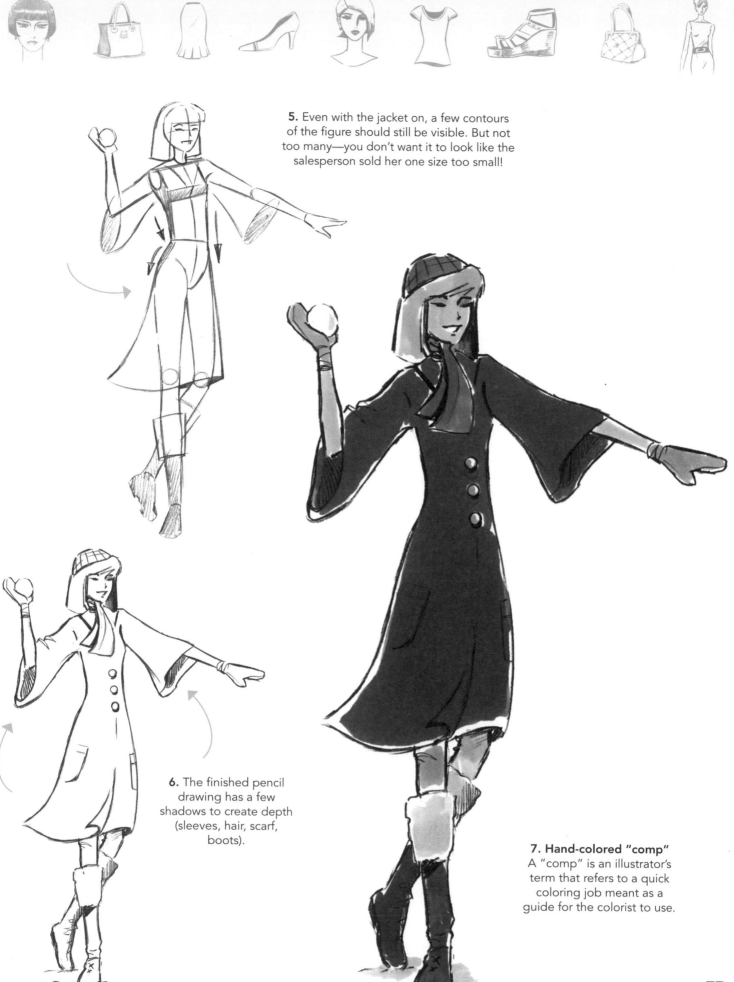

5. Even with the jacket on, a few contours of the figure should still be visible. But not too many—you don't want it to look like the salesperson sold her one size too small!

6. The finished pencil drawing has a few shadows to create depth (sleeves, hair, scarf, boots).

7. Hand-colored "comp"
A "comp" is an illustrator's term that refers to a quick coloring job meant as a guide for the colorist to use.

walking **pose**

This is a fast, carefree walk. We can tell she has a buoyant spirit because of the way her limbs have been drawn: swinging away from the body, unconstricted. It's a pleasing woman-on-the-go type of walk. As in the standing pose, the spine retains its curves, so that the torso doesn't appear stiff. Note how her front arches out, but her back arches in.

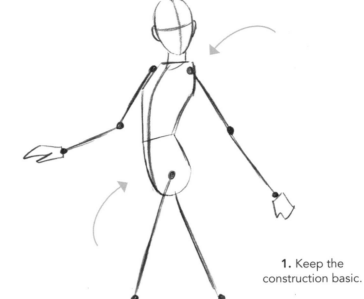

1. Keep the construction basic.

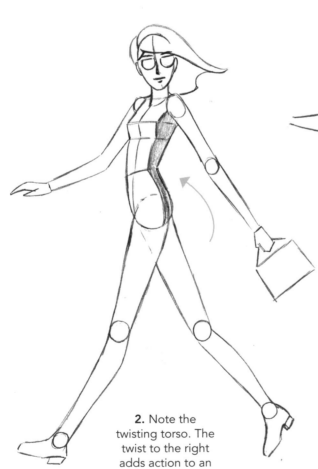

2. Note the twisting torso. The twist to the right adds action to an otherwise flat drawing.

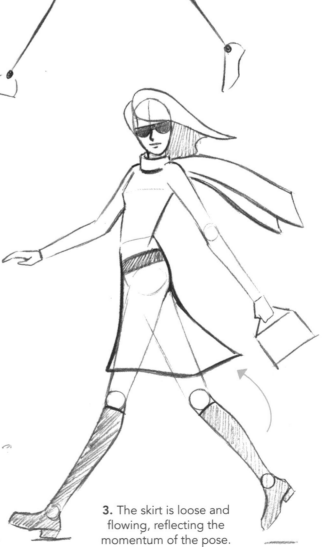

3. The skirt is loose and flowing, reflecting the momentum of the pose.

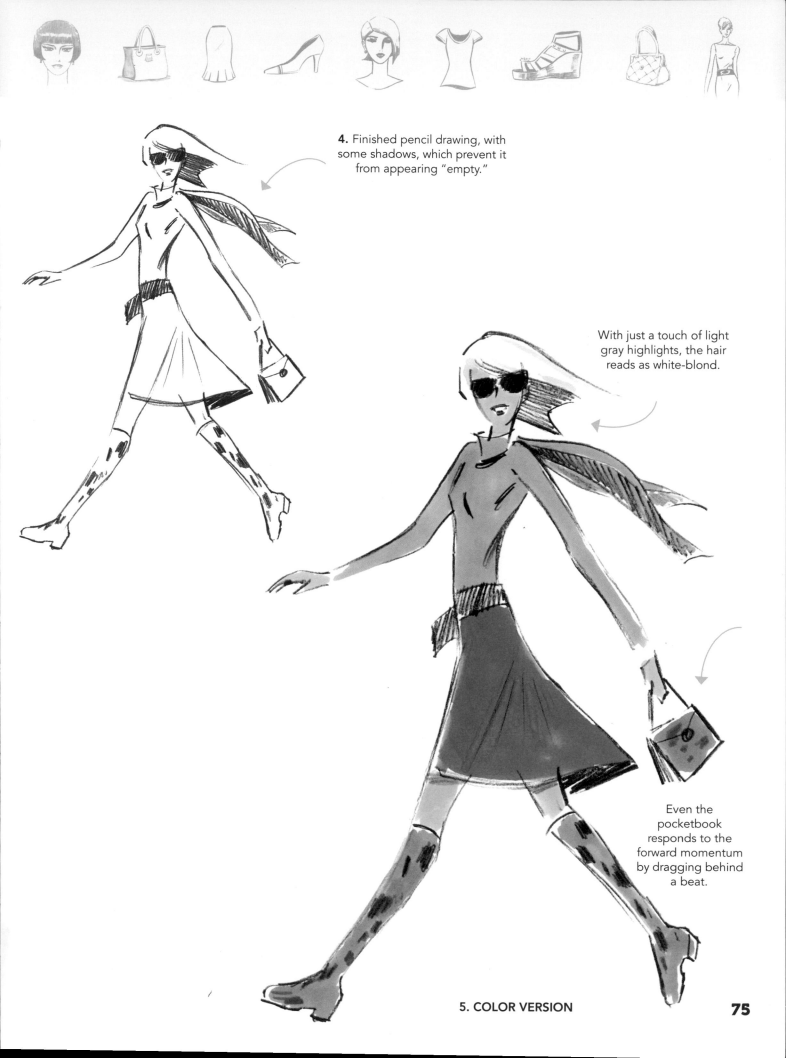

4. Finished pencil drawing, with some shadows, which prevent it from appearing "empty."

With just a touch of light gray highlights, the hair reads as white-blond.

Even the pocketbook responds to the forward momentum by dragging behind a beat.

5. COLOR VERSION

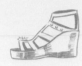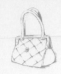

fashion
standing pose

A typical fashion pose does not have to look completely, caught-off-guard natural. Rather, it can be a casual pose, in which the model is aware of her own attractiveness, yet is aloof to it, retaining a moody, faraway persona.

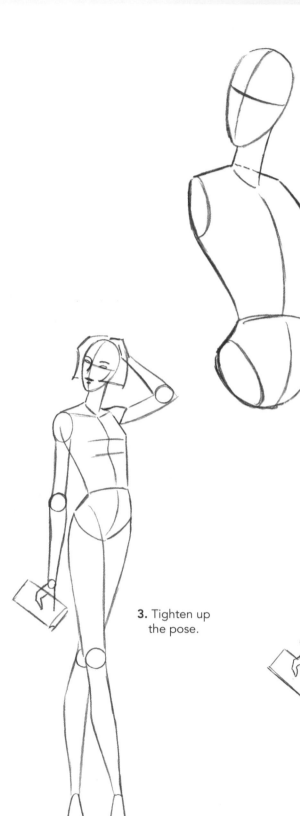

1. Torso faces page-right in a three-quarter view, while the head faces page-left in a three-quarter view.

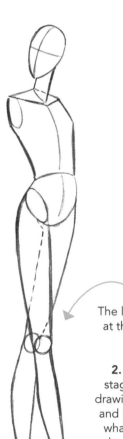

The legs cross at the knees

2. At this stage in the drawing, pause and look over what you've done. Make any needed adjustments before continuing to the final image.

3. Tighten up the pose.

4. There is a pleasing symmetry to the length of the garment: the top is cut low and the bottom is cut high.

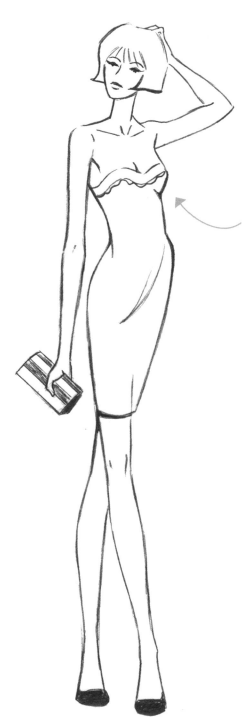

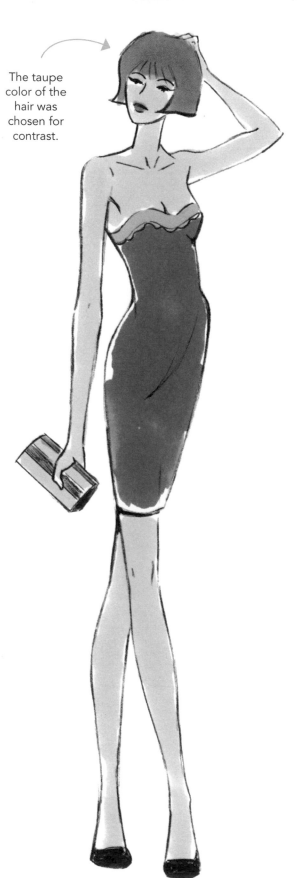

The taupe color of the hair was chosen for contrast.

5. FINISHED PENCIL DRAWING
Owing to the brightness of the final colors, most shadows have been eliminated from this figure, to reduce the intensity and keep it cheerful.

6. COLOR VERSION

draw it yourself: fashion pose

Explore creating your own looks by drawing over these figures.

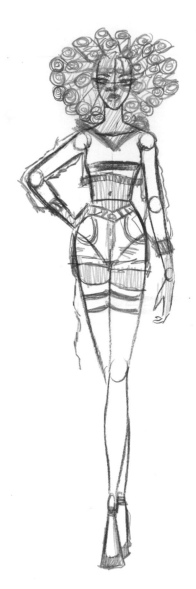

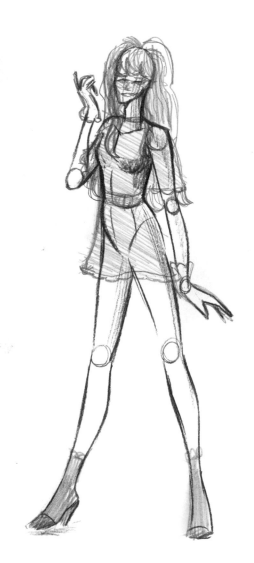
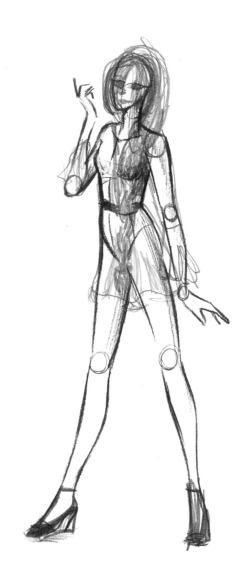

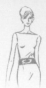

style file: **fashions & outfits**

Now we come to the part of the book we've been building toward and the part that you've been looking forward to: drawing an assortment of stylish and trendy fashions.

This useful section is more than a tutorial; it's also a resource, a collection of material you can refer to for your drawing. You can draw these popular pieces just as they are, or you can make some adjustments, changing the cut, style, length, collar, patterns, buttons, belts, and more to reflect your own personal style and taste.

In this section, I'm going to present different, essential categories of clothes according to type (blouses, skirts, etc.). As you work through them, try to keep a few points in mind:

- Elongate the proportions. Remember, fashion drawing features stylized figures.
- Select a pose that will allow the clothes to share the stage with the figure.
- Keep folds and creases to a minimum, but draw them with authority.
- Be specific in creating the look of the outfit. Don't be afraid to make bold decisions.
- Use flowing, long lines wherever possible.
- Have fun being creative—that spirit will translate to the viewer by way of your illustrations.

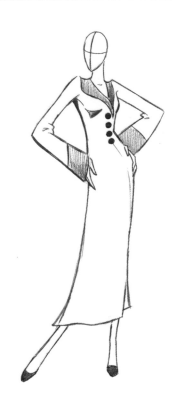

Sophisticated long coat

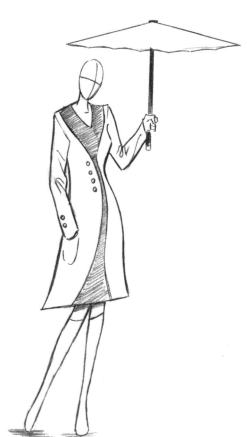

Spring coat

Traditional peacoat

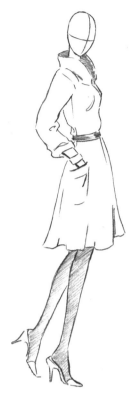

Lightweight coat

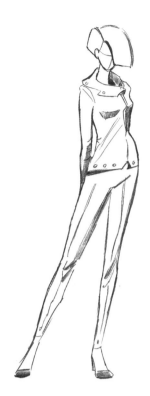

Chic tailored jacket

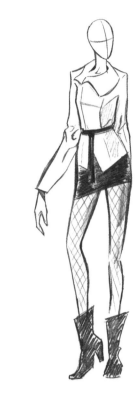

Trendy jacket

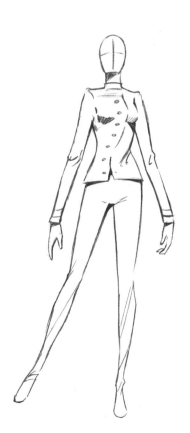

Asymmetrical jacket

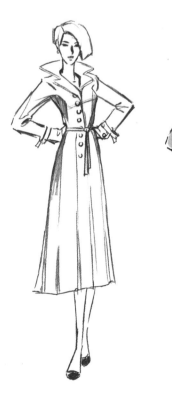

Belted coat—sketch and color rough

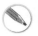
draw it yourself: jackets & coats

Try drawing your own coat or jacket designs over these figures.

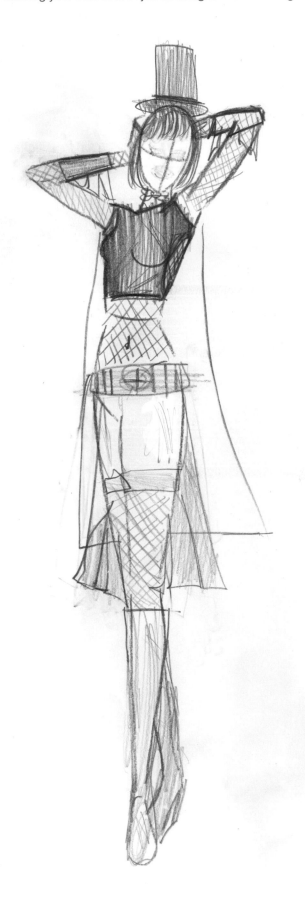

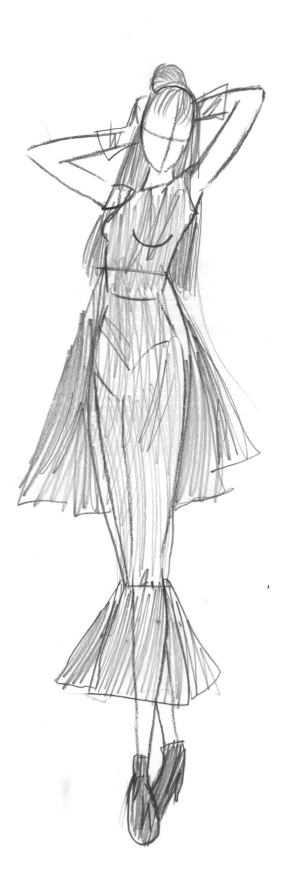

blouses **& shirts**

Scoop neck

Peplum top

Buttoned blouse

Flowing camisole

Loose tank

Cap-sleeve top

Long vest

Sleeveless mock turtle

Button-down tank

short-sleeve

83

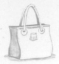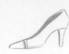

long-sleeve

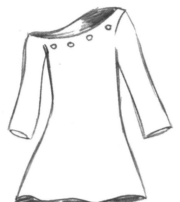

Jazzy bell-sleeve top

Asymmetrical top

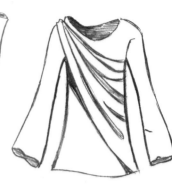

Scoop-neck long-sleeve T

Ruched top

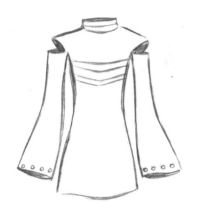

Detailed top

Boatneck

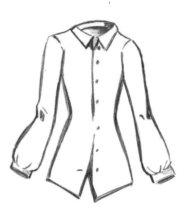

Button-down long-sleeve

Button-down peplum

Scoop with three-quarter-length sleeves

Double-pocketed button-down

Traditional button-down

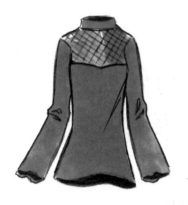

draw it yourself: blouses, shirts, & vests

Experiment with necklines, sleeve length, and details by drawing your own designs over these figures.

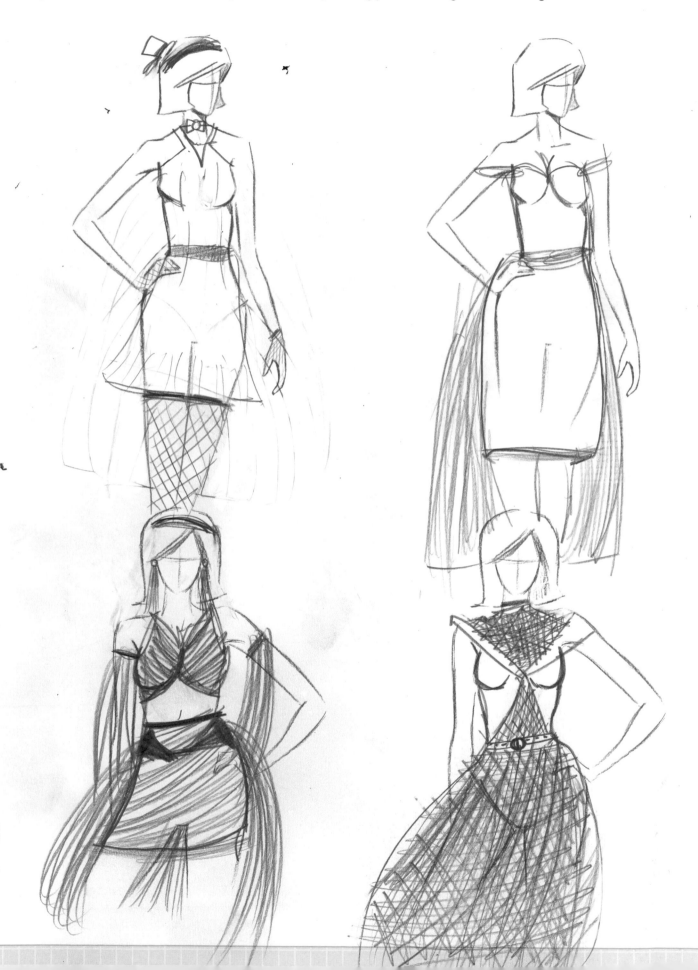

pants

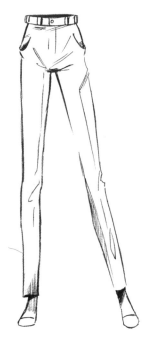

High-waist cigarette pants

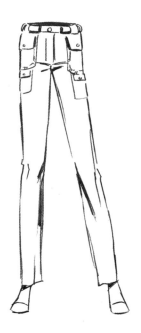

Cargo pants

Slim ankle pants

Distressed jeans

Palazzo pants

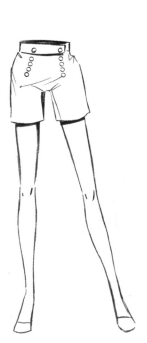

Bell bottoms

Sailor shorts

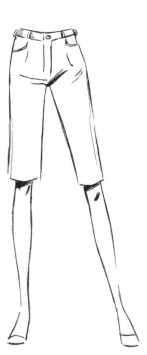

Walking shorts

Flared skirt

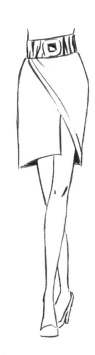

Split crossover skirt

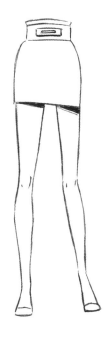

Mini skirt

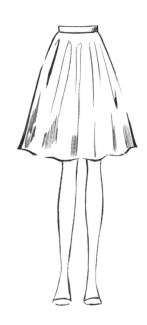

Circle skirt

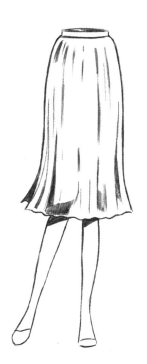

Soft, over-the-knee skirt

Pencil skirt

Over-the-knee wrap skirt

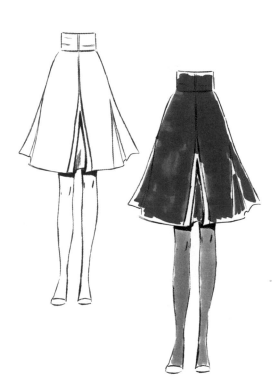

Split vent—sketch and color rough

draw it yourself: pants & skirts

Use these figures to create your own skirts, pants, and shorts.

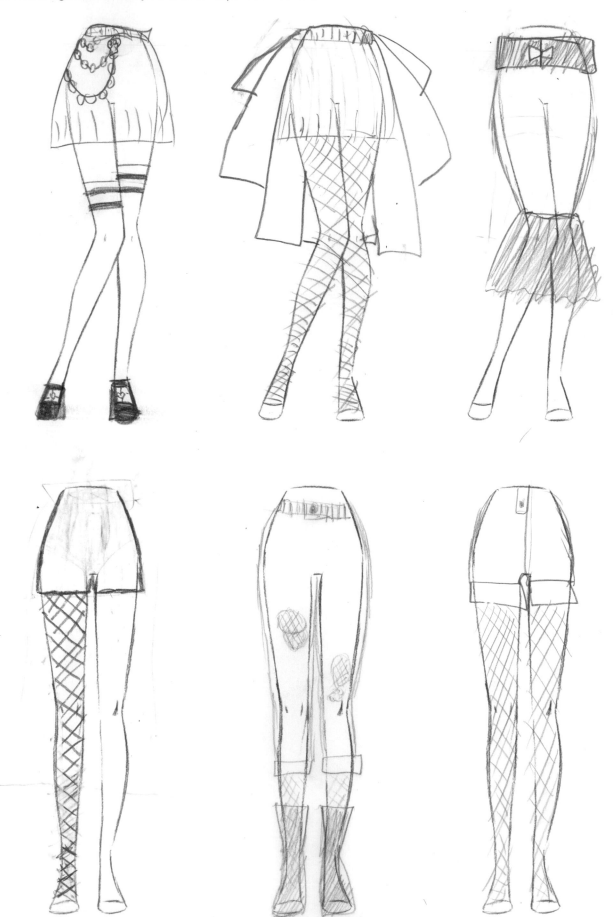

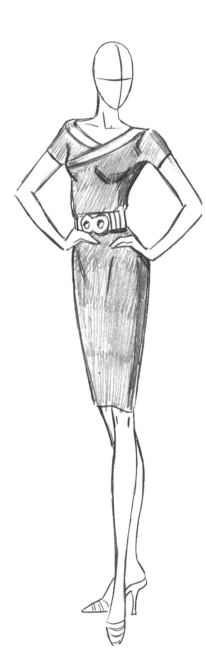

Belted surplice-neck dress

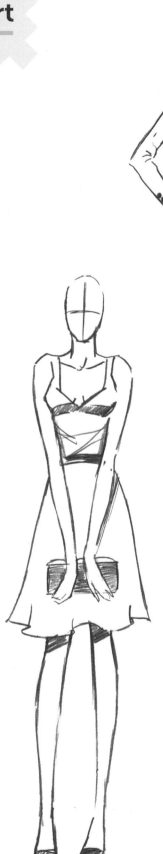

Soft-scoop
sheath dress

Sweetheart-neckline sundress

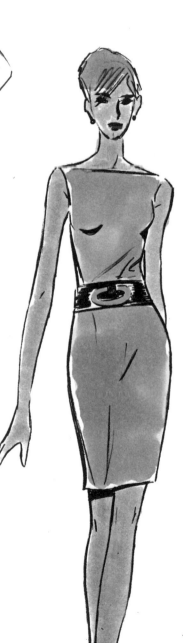

Sleeveless boatneck
sheath dress

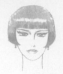
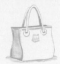

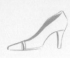

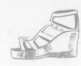
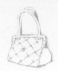

dresses—long

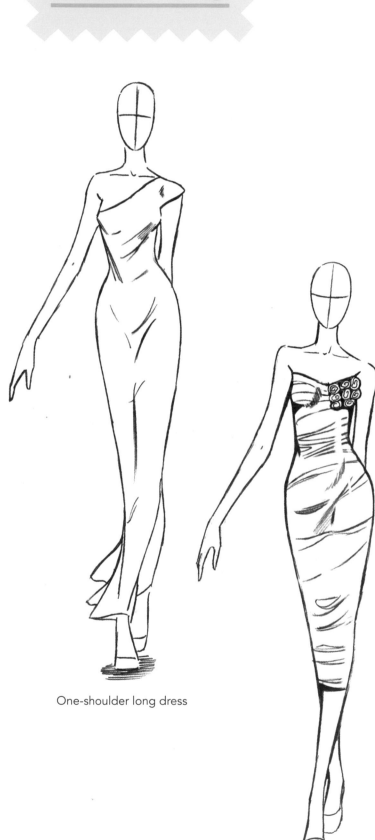

One-shoulder long dress

Strapless dinner dress

Soft, flowing mid-calf dress

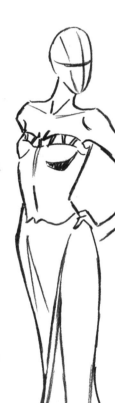

Strapless sundress

draw it yourself: dresses

Draw over these figures to design your own dresses or gowns.

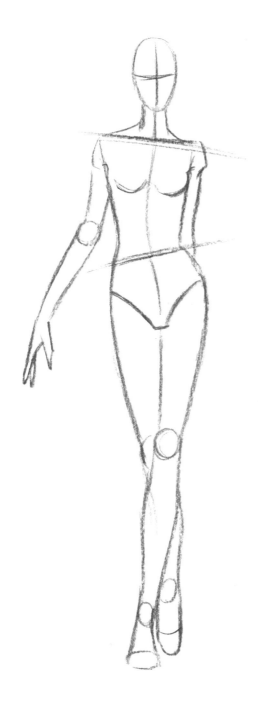

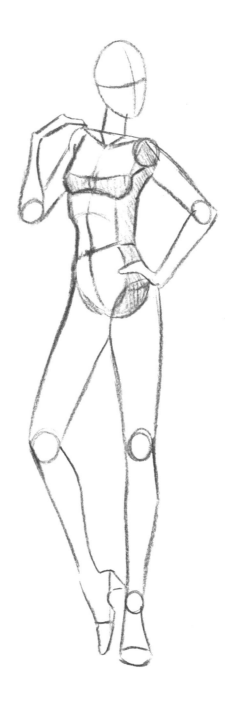

complete **looks**

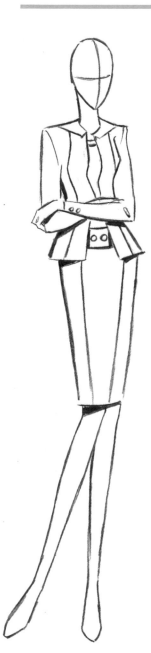

Pencil-skirt suit

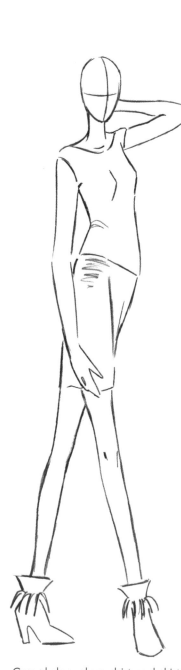

Casual sleeveless shirt and skirt

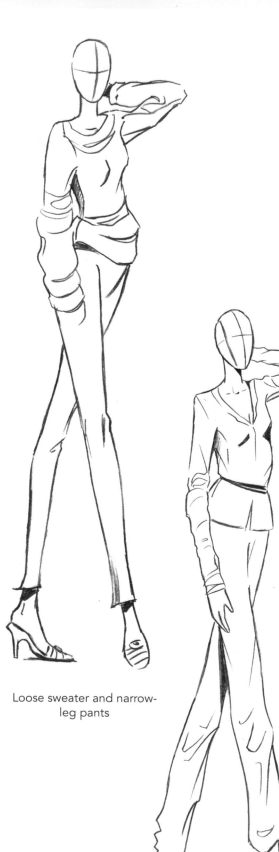

Loose sweater and narrow-
leg pants

Slouchy pants with belted blouse

92

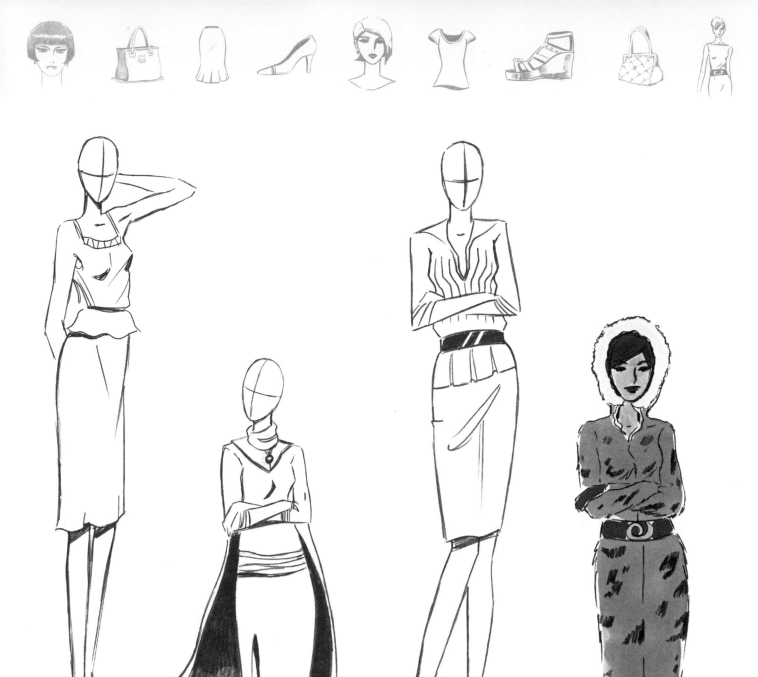

Peplum top and soft skirt

Cape and pencil skirt

Belted top and pencil skirt

Faux-fur hooded coat

draw it yourself: complete looks

Use these figures to create your own head-to-toe looks.

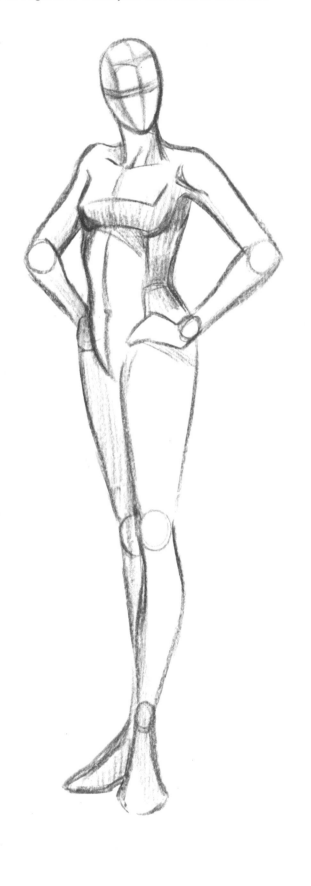

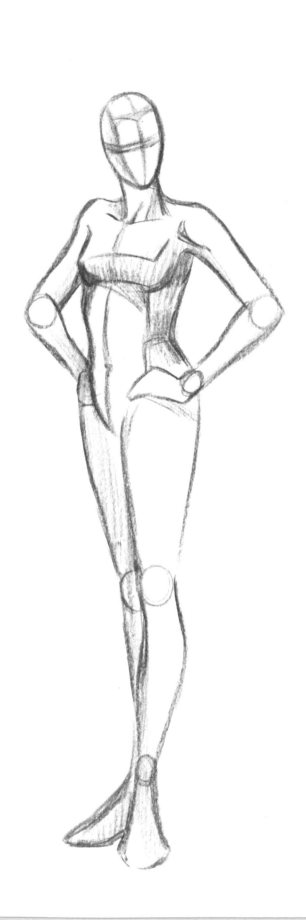

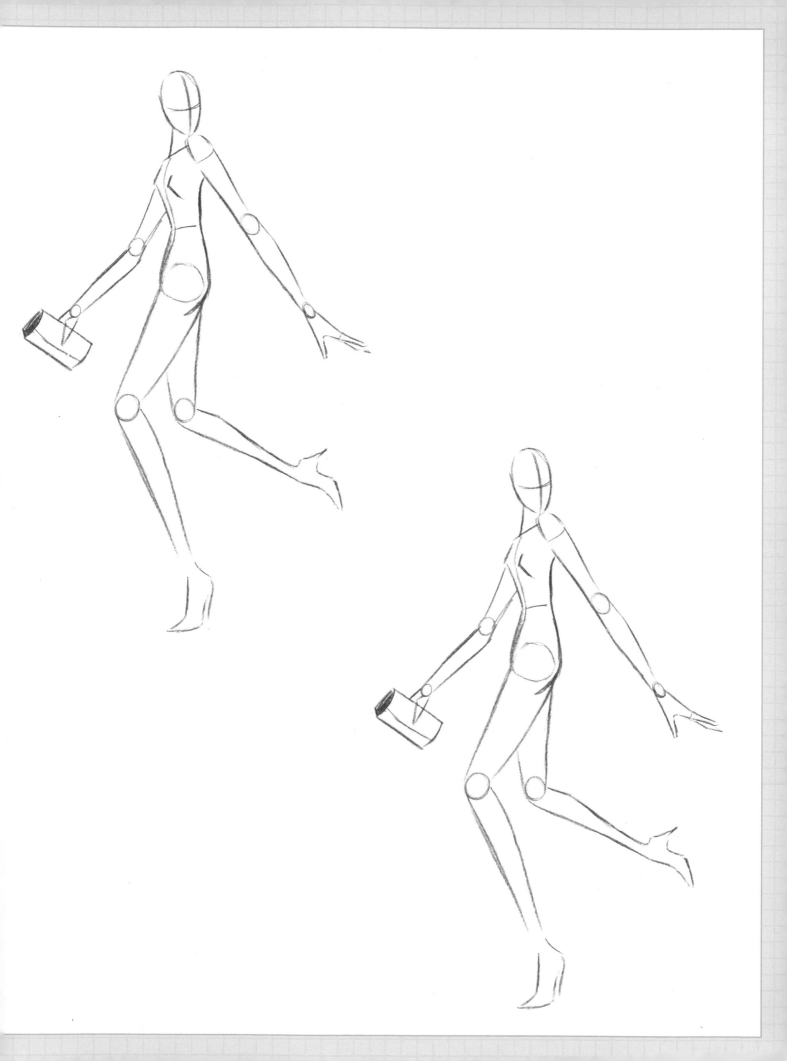

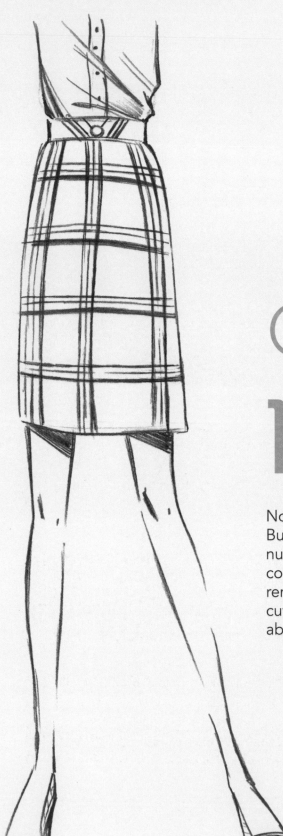



creating
prints

Not all clothing has, or should have, patterns. But certainly, you're going to want to use a good number of them if you want your fashions to look contemporary, and to pop off the page. People often remember an outfit as much for the pattern as for the cut. At this point, let's introduce a few simple principles about how to draw patterns on the clothed figure.

5

color roughs—swatches of patterns

ABOUT COLOR: Many fashion illustrations are in black and white, and often include gray tones. If you're working your way through this book with only a pencil or a pen, you can create these same patterns in black and white with varying degrees of gray.

Before you decide on a pattern for an outfit, rough out a few designs. Create a few swatches of patterns, and add a variety of colors. Don't restrict yourself. This is where you try things out. Not everything will work. Doesn't matter. Experiment. Hold your drawing next to some of the swatches, and see which one catches your eye. Then go with that, or a combination of two or more. Here are a few popular types of patterns to get you started:

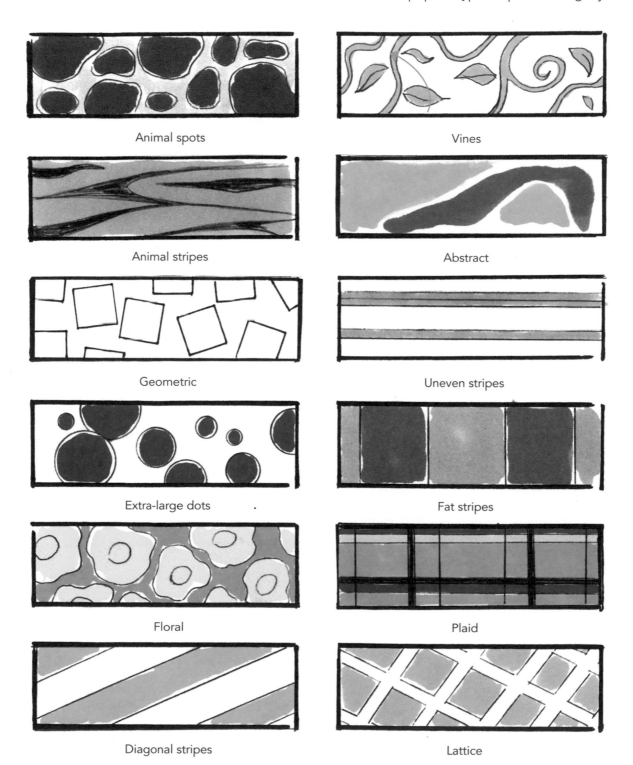

Animal spots

Vines

Animal stripes

Abstract

Geometric

Uneven stripes

Extra-large dots

Fat stripes

Floral

Plaid

Diagonal stripes

Lattice

 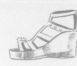 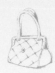

basic **principles**

If you were to draw checks on a clothed figure without taking into account the contours of that figure, it would look like an optical illusion. Flat squares on a rounded body are not possible. It's necessary to take into account the shape of the clothing, folds, and creases when applying any pattern. By drawing a pattern so that it reflects the folds of the clothing and the contours of the body, you get an added bonus: it highlights the three-dimensional aspect of the figure.

Clothing isn't a tablecloth; you must disturb the pattern

stripes

Stripes, undisturbed, are straight, just as they would appear on a tablecloth. But clothes aren't tablecloths, so we'll have to do a little extra work. Interrupted by folds and creases, stripes appear, break up, and come back together again.

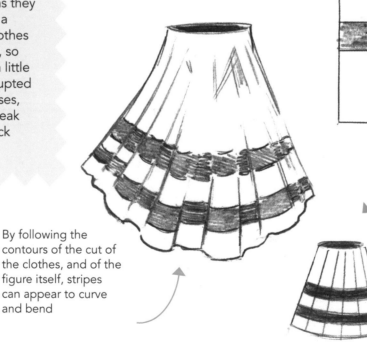

By following the contours of the cut of the clothes, and of the figure itself, stripes can appear to curve and bend

If you do not break up the stripes ocassionally on clothes, you'll end up turning the dress into what looks like a lampshade!

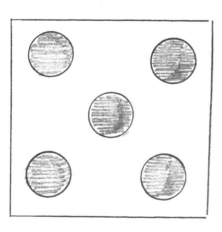

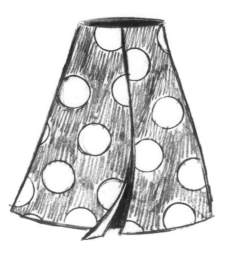

polka dots

To make the placement of the dots appear natural, show complete dots mixed in with partial dots that have been cut off by the edges of the fabric.

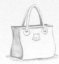

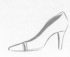

plaids

Plaids are different-colored lines of varying thicknesses. Instead of thinking of them as straight lines, think of them as lines that travel the length or width of the body. The body looks like it has a bunch of flat surfaces, but actually, it's mostly rounded or curved, but in a subtle way. The plaid lines will follow those subtle curves, making the figure appear lifelike and the clothes fitted and natural-looking.

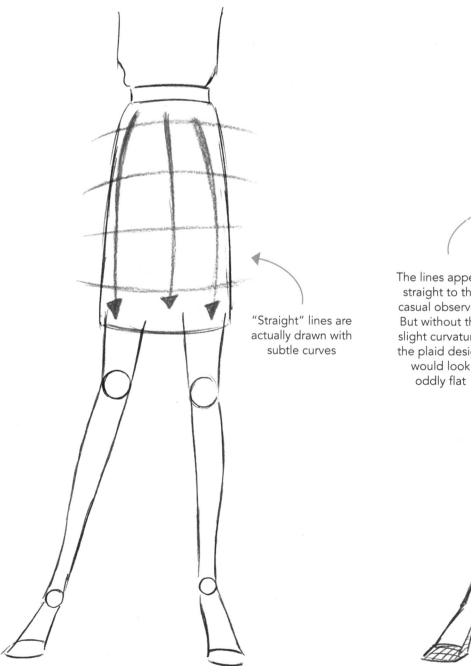

"Straight" lines are actually drawn with subtle curves

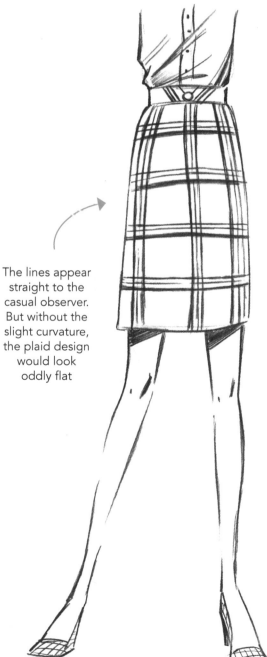

The lines appear straight to the casual observer. But without the slight curvature, the plaid design would look oddly flat

floral & **organic patterns**

Non-geometic patterns, whether they're flowers or snowflakes, are treated in a similar way to dots: they are more convincing if they are cut off at the edges of the outfit. The randomness with which the shapes are cut off makes it appear to have occurred naturally. It's "purposeful" randomness!

To create an even more effective look, draw the patterns so that portions of the design will fall into the folds and creases of the garment. Allow the folds and creases to dictate which parts of the pattern are visible.

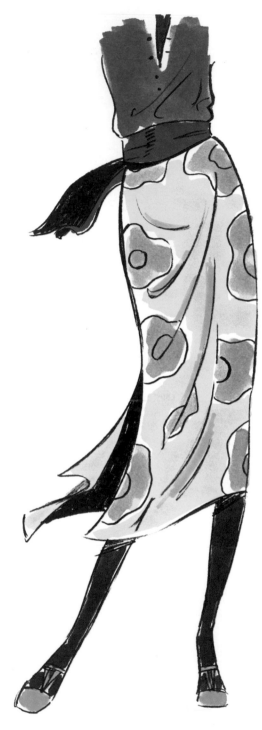

Final color version

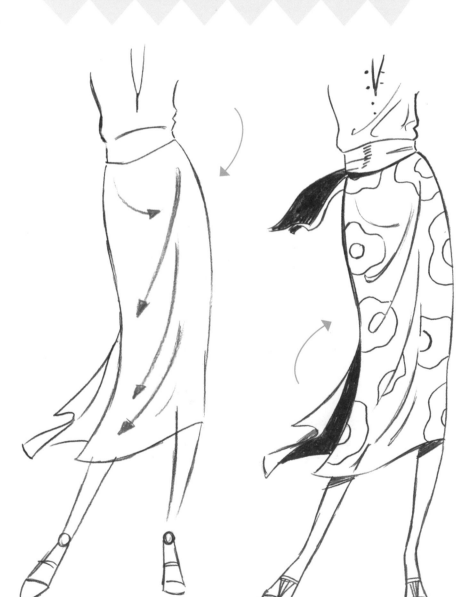

Direction of creases

The folds affect the pattern and design

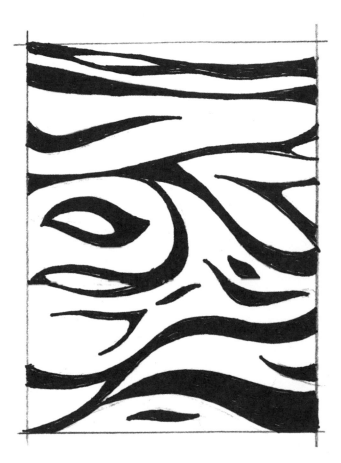

variations
on a theme

You can take any standard pattern, add a twist to it, and make it jazzier, more geometric, larger, or smaller. The variations are endless, and they personalize your style of art. Here, I've taken a typical zebra pattern (at left), and instead of horizontal stripes I've added a swirling motion, to create a livelier look.

In the second pattern (at right), I've closed the stripes to give it a '60s type of look—it's like a combination of zebra and lava lamp!

draw it yourself: prints

Use these boxes to practice drawing your own unique prints.

drawing patterns on
the clothed figure

We've covered a lot of material in this book. Now we're going to apply it all to create our complete fashion figures. We'll take what we know about figure drawing, folds and creases, outfits, and patterns to create super-cool fashion models.

Again, if you're not using color, no problem! A great many fashion illos are done in black and white. But if you do plan on using color, this section will make the most of it.

vertical **stripes**

This pose, in particular, shows that patterns conform to the figure and not the other way around. And you don't have to strive for 100 percent accuracy. Remember that we're creating an image, a mood, a feeling, and glamour. It's not supposed to be a photograph.

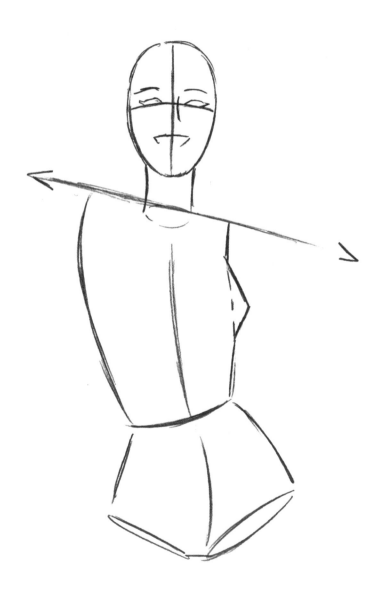

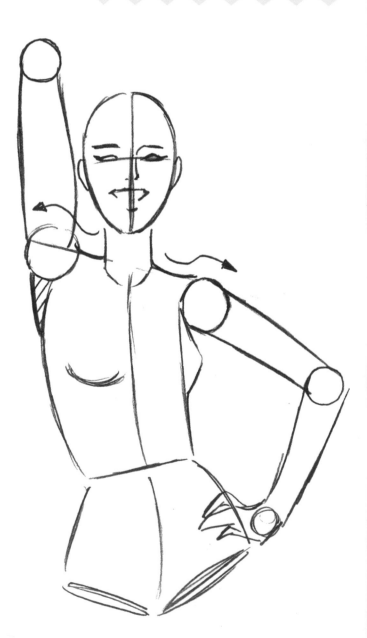

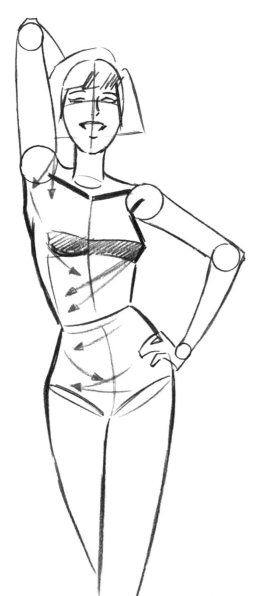

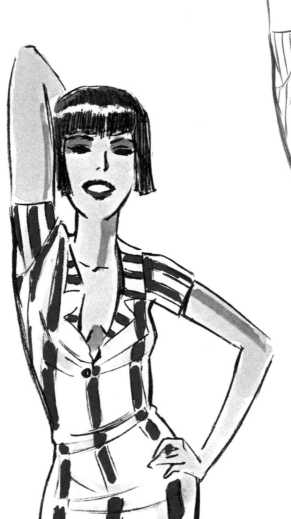

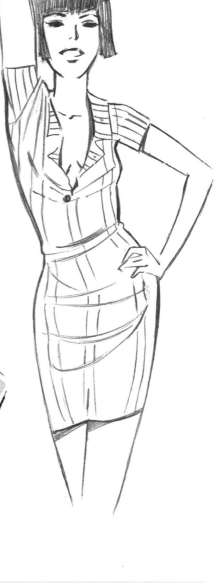

You might think that if you leave an area of clothing empty, it will read as "white" when drawn on a white page. Actually, it will read as "empty." It needs some subtle tone or shading. Even the suggestion of shadow is enough to counter the empty look, which, at its worst, looks like a printing error.

Light gray highlights on white clothes don't make them appear dirty or dreary. Instead, they give the drawing a three-dimensional appearance. But be moderate in your application of shading, or it will look like a gray dress with white highlights.

draw it yourself: prints on a clothed figure

Draw your fashions over these figures, then add your own prints.

Tiana

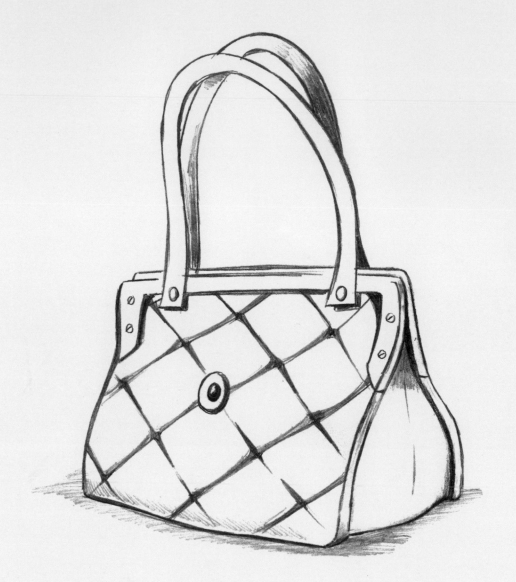

designing
accessories

No look is complete without accessories to complement the clothing.
And the same goes for fashion drawing: the right hat, bag, or shoes, drawn in
the most natural-looking and attractive way, can add sparkle and individuality
and help evoke the specific mood or style you have in mind. Let's take a look at
some of the accessories you can use to spice up your designs.

angles of **the shoe**

If the question is, "How do you draw a shoe?" then the answer should be, "In what position?" One angle does not fit every pose. Therefore, try drawing some roughs of these angles, to get your feet wet. (Sorry about the pun.)

Detail of the foot inside the shoe—note the extra length past the toes

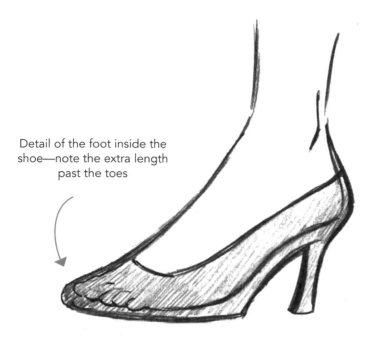

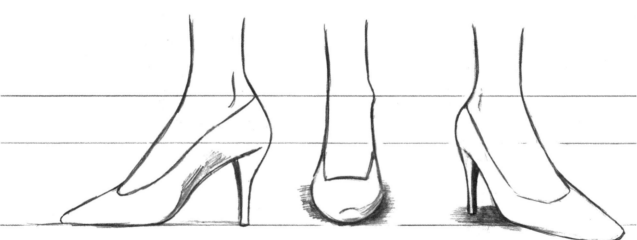

Side view—arch side Front Three-quarter view—outside

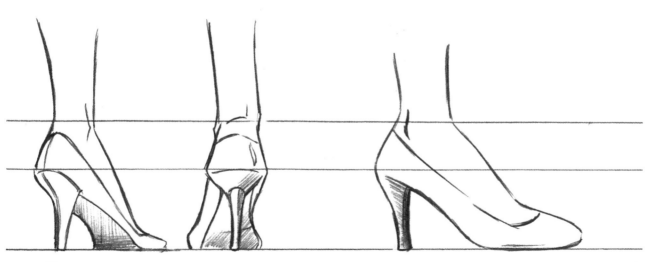

Three-quarter rear Rear Side view—outside

style file: **shoes & boots**

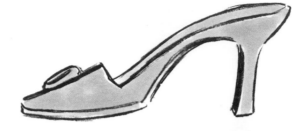

Slipper shoe

Mule

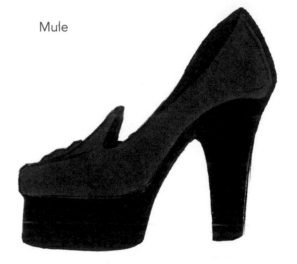

High-heel sandal

Platform shoe

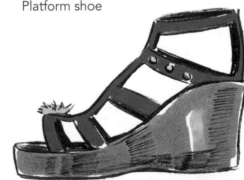

Open-toe high heel

Platform sandal

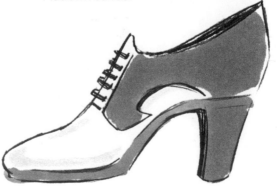

Pump

Laced heel

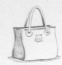

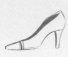

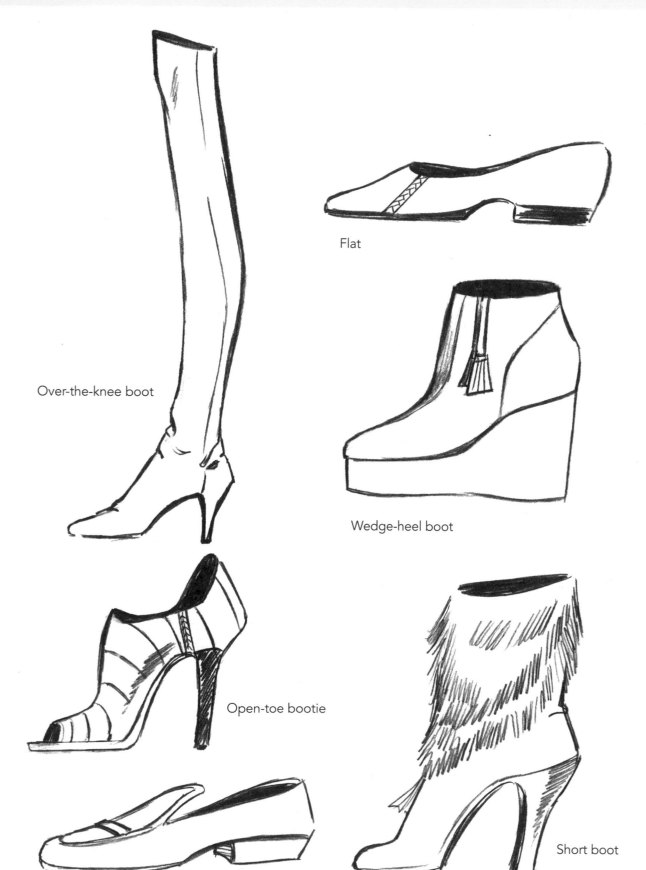

Flat

Over-the-knee boot

Wedge-heel boot

Open-toe bootie

Short boot

Loafer

 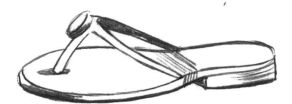 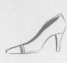 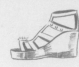 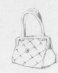

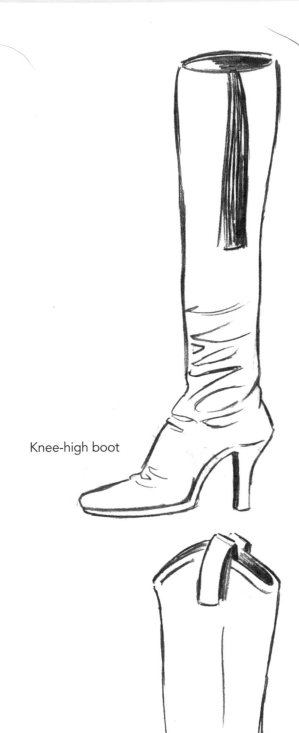

Knee-high boot

Cowboy boot

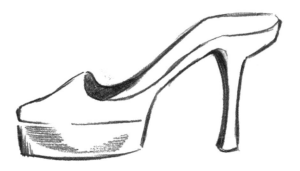

Thong

Platform mule

Ballet flat

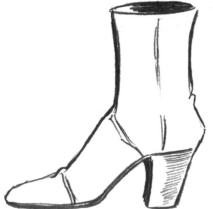

Chunky heel

draw it yourself: shoes & boots

Create your own shoes and boots using these drawings as a guide.

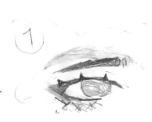

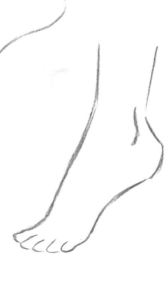

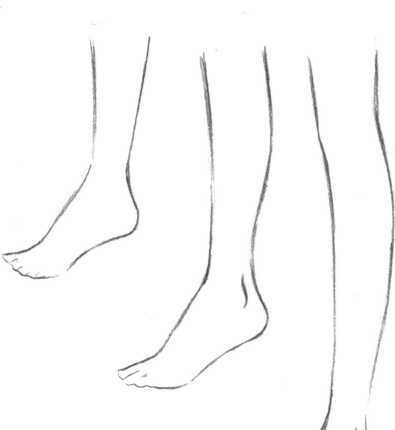

drawing **bags**

Bags are three-dimensional objects being represented on a two-dimensional piece of paper. To be fair, everything we draw is supposed to give the illusion of being three-dimensional. However, few things display their dimensionality as prominently as a box. And that's what a bag really is—a modified box. As you can see from the examples, depth is indicated by the diagonal lines that represent the shorter sides.

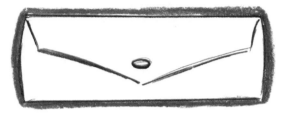

Front view—no depth necessary

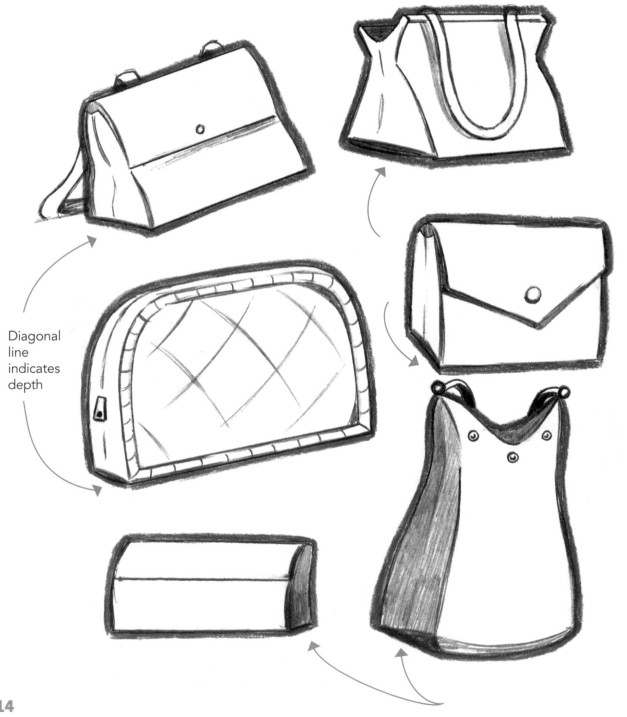

Diagonal line indicates depth

style file: **bags**

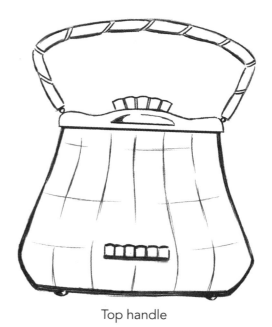

Top handle

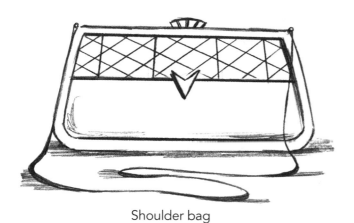

Shoulder bag

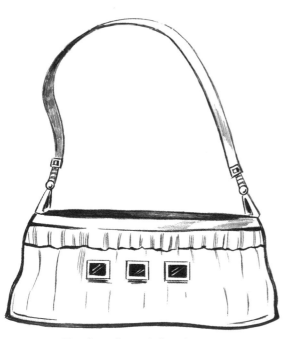

Top handle with hardware

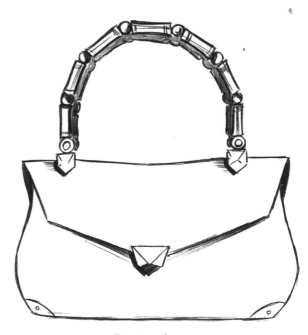

Evening bag

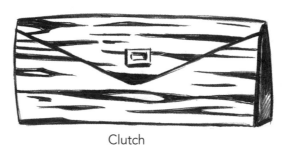

Clutch

Double-handle
day shopper

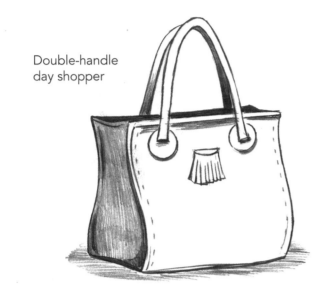

Shoulder bag

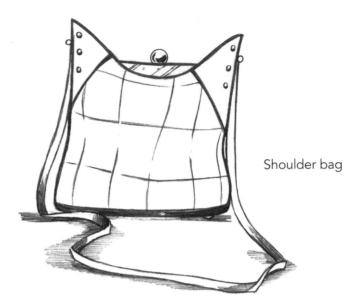

Structured
shoulder bag

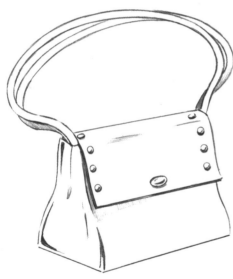

Top-handle
structured bag

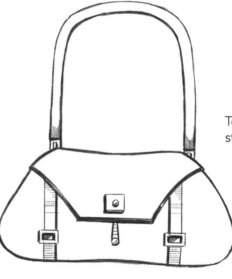

Double-handle
structured bag—
sketch and color
rough

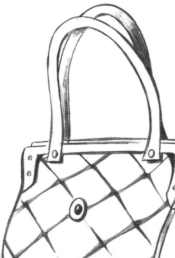

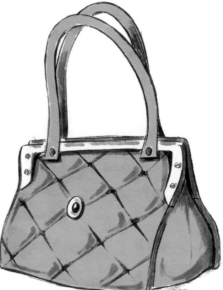

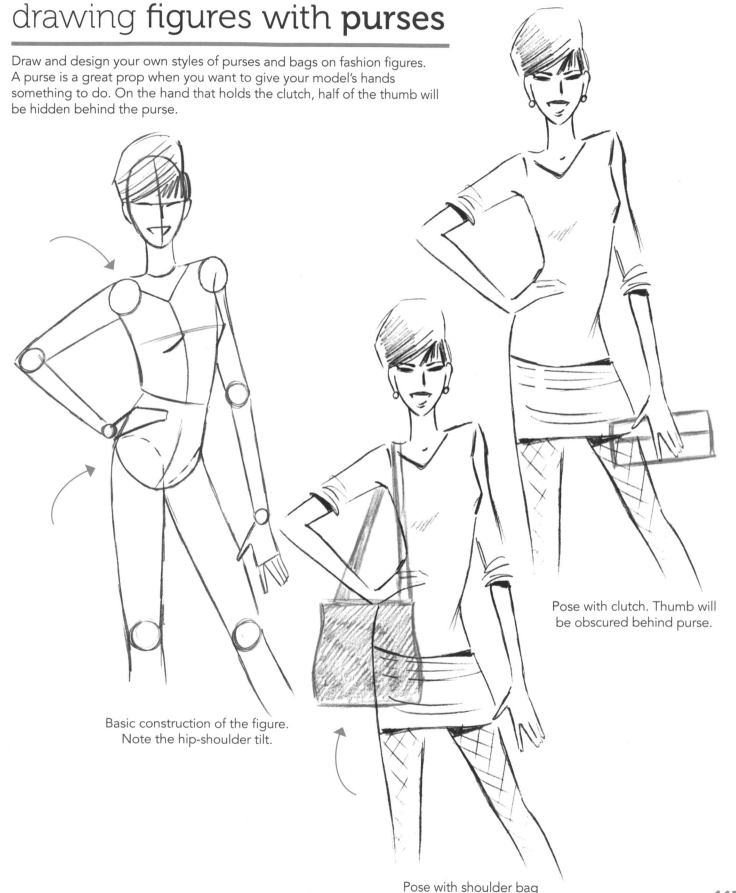

drawing figures with purses

Draw and design your own styles of purses and bags on fashion figures. A purse is a great prop when you want to give your model's hands something to do. On the hand that holds the clutch, half of the thumb will be hidden behind the purse.

Basic construction of the figure.
Note the hip-shoulder tilt.

Pose with clutch. Thumb will
be obscured behind purse.

Pose with shoulder bag

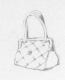

drawing figures with **clutches & handbags**

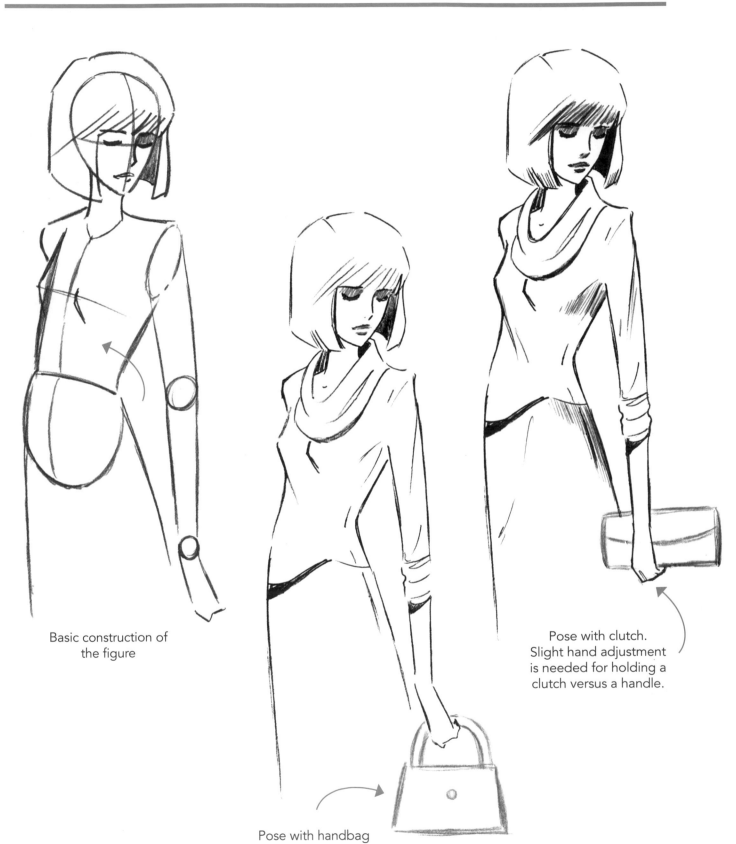

Basic construction of
the figure

Pose with handbag

Pose with clutch.
Slight hand adjustment
is needed for holding a
clutch versus a handle.

draw it yourself: purses & clutches

Add your purse or clutch designs to these figures.

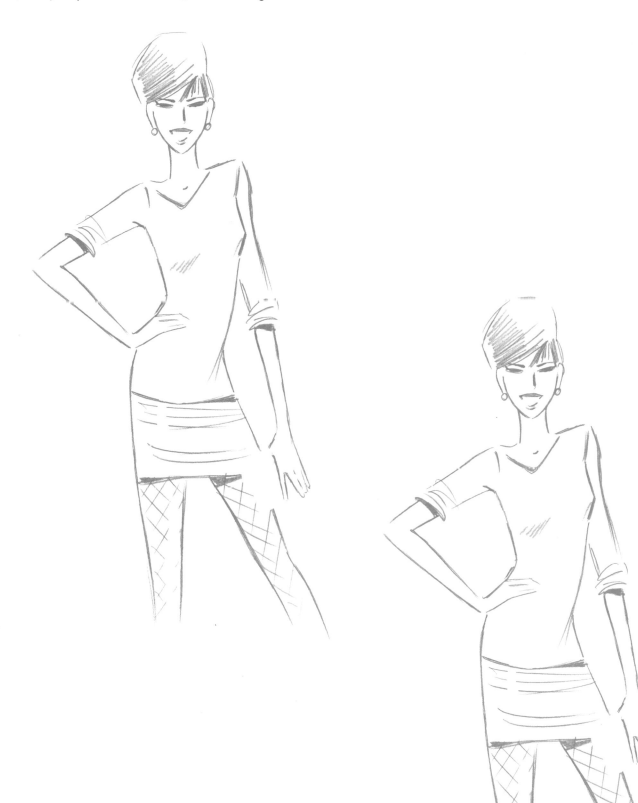

hats

From time to time, people prognosticate that women's hats will go the way of the fedora, but of course, they're not going anywhere. Hats remain as popular as ever because there are so many cool looks they can create. Hats can be oversized, bold, and kicky, without being over-the-top. For example, a sun hat is actually a gigantic disk. So don't be too restrained in your approach to drawing the proportions of a hat.

hat **construction**

A hat is really a slice of a cone, mounted on a platform. Although the platform is a circle, perspective makes it appear as an oval-shaped disk.

"up" or "down" **views of the hat**

When drawing a hat, you need to decide whether to show it from an angle slightly above, or slightly below. In the "up" position, some of the underside of the hat is visible. In the "down" position, some of the top portion of the hat is visible.

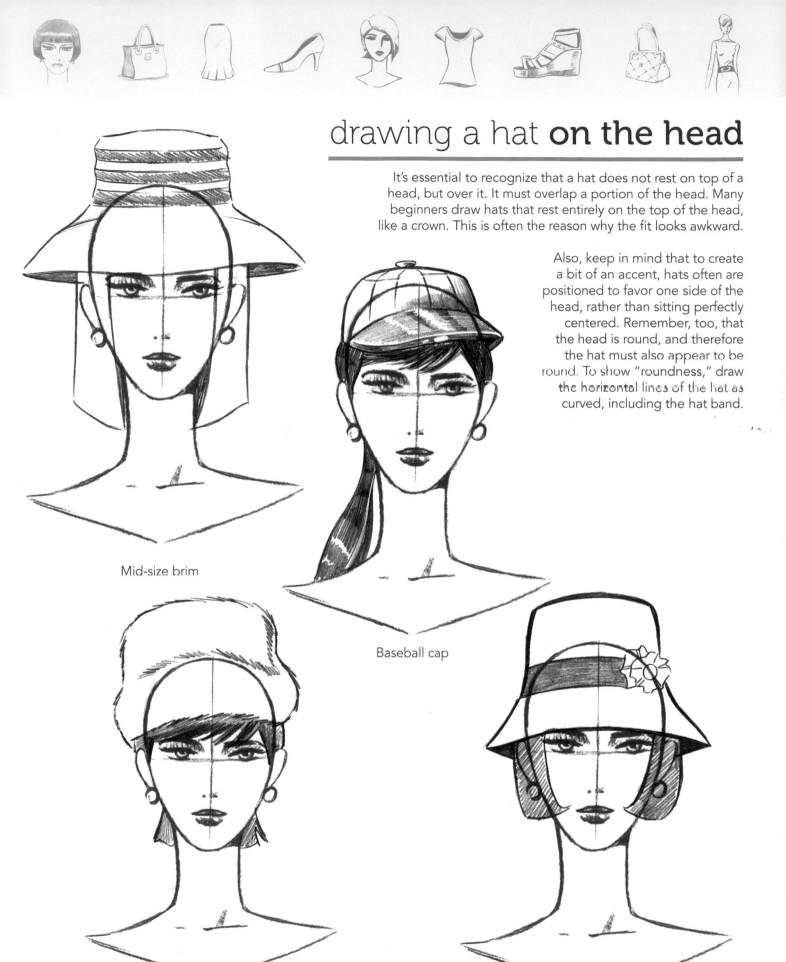

drawing a hat **on the head**

It's essential to recognize that a hat does not rest on top of a head, but over it. It must overlap a portion of the head. Many beginners draw hats that rest entirely on the top of the head, like a crown. This is often the reason why the fit looks awkward.

Also, keep in mind that to create a bit of an accent, hats often are positioned to favor one side of the head, rather than sitting perfectly centered. Remember, too, that the head is round, and therefore the hat must also appear to be round. To show "roundness," draw the horizontal lines of the hat as curved, including the hat band.

Mid-size brim

Baseball cap

Fur hat

Ribboned hat

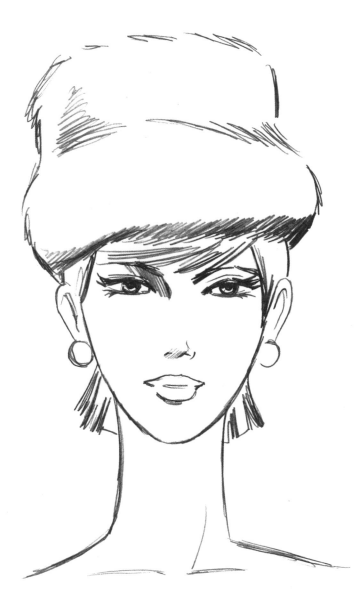

Clean pencil sketch

A well-designed hat commands a sense of presence. The model gains an added measure of impact and stature, due to the extra height. Color can add a bit of fun, and indicate the season by showing autumnal, summer, or holiday colors.

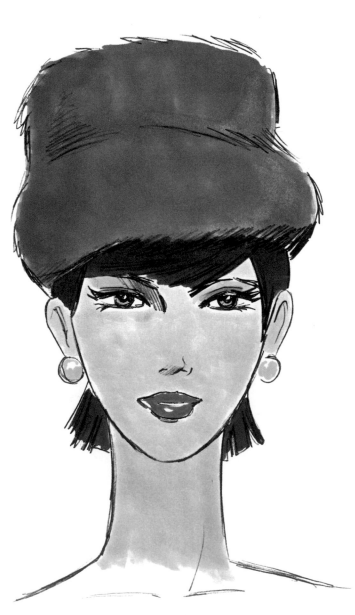

Color rough

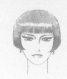 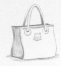 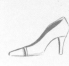

style file: **hats**

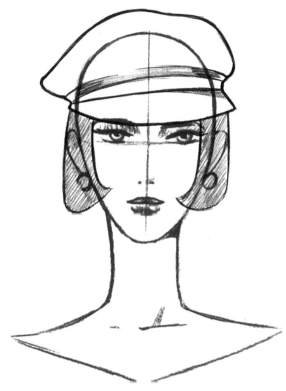

Pageboy cap

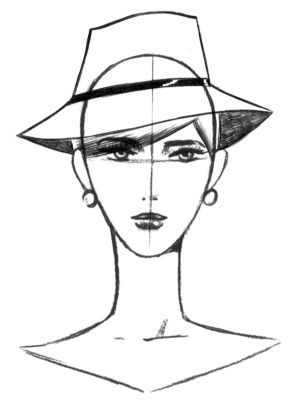

Thin leather band

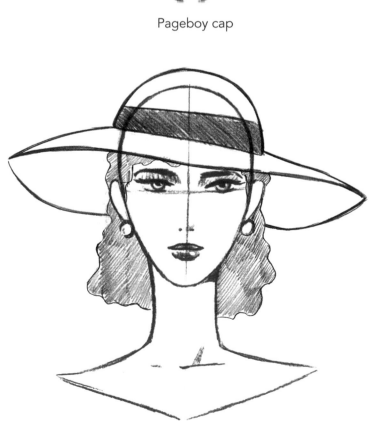

Wide brim

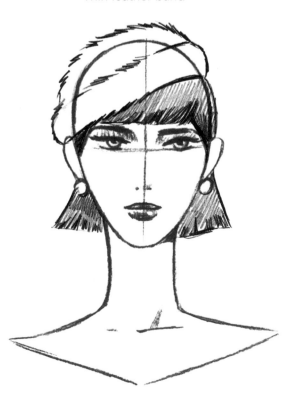

Fur cap

draw it yourself: hats

Use these heads to create unique hat designs.

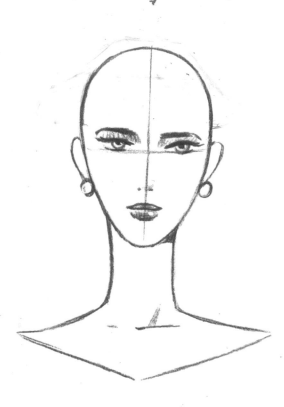
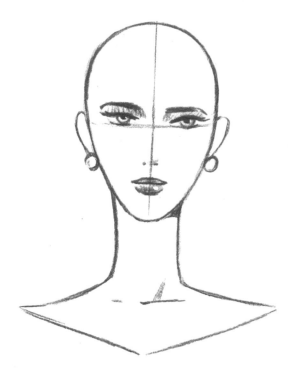
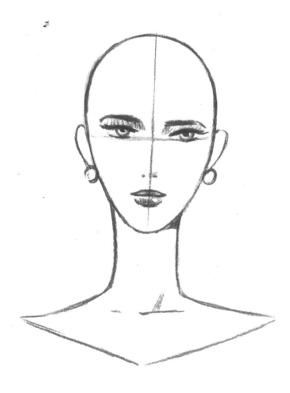
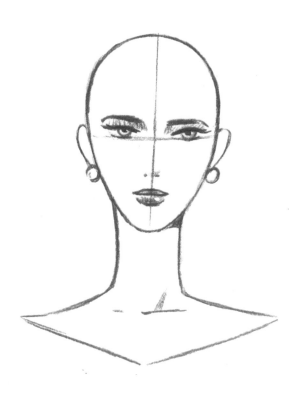

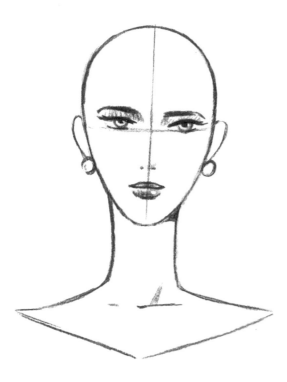
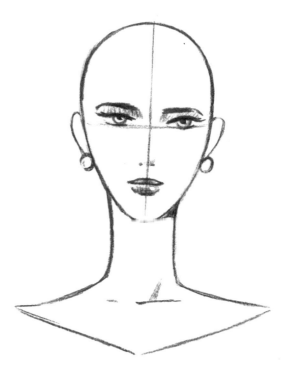
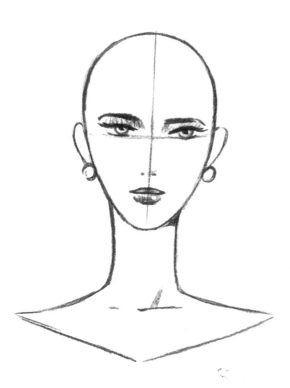
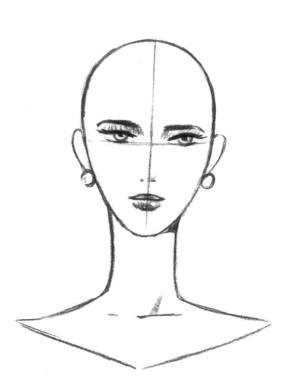

resources

Visit these websites for information, education, and supplies!

Art and Design Schools

California College of the Arts
San Francisco, CA
www.cca.edu

Fashion Institute of Design & Merchandising
Los Angeles, CA
fidm.edu

Fashion Institute of Technology (FIT)
New York, NY
www.fitnyc.edu

Otis College of Art and Design
Los Angeles, CA
www.otis.edu

Parsons, the New School for Design
New York, NY
www.newschool.edu/parsons

Pratt Institute
Brooklyn, NY
www.pratt.edu

Rhode Island School of Design
Providence, RI
www.risd.edu

Savannah College of Art and Design
Savannah, GA
www.scad.edu

School of the Art Institute of Chicago
Chicago, CA
www.saic.edu

Art Supply Sources

A. I. Friedman
www.aifriedman.com

Artist & Craftsman Supply
www.artistcraftsman.com

Da Vinci Artist Supply
www.davinciartistsupply.com

Dick Blick Art Materials
www.dickblick.com

Lee's Art Shop
www.leesartshop.com

New York Central Art Supply
www.nycentralart.com

Pearl Fine Art Supplies
www.pearlpaint.com

Utrecht Art Supplies
www.utrechtart.com